IMAGES
of Rail

RAILROADS OF
NORTH CAROLINA

ON THE COVER: M. B. "Mac" Connery of Durham was only a few weeks away from leaving for military service when he made a trip to Fayetteville, North Carolina, in 1951. A second-generation professional photographer, Connery captured this beautiful shot of Aberdeen and Rockfish Railroad's No. 201 (a 1948-vintage EMD F-5A) and an unknown trainman in the Fayetteville yard.

IMAGES
of Rail

RAILROADS OF
NORTH CAROLINA

Alan Coleman

ARCADIA
PUBLISHING

Published by Arcadia Publishing
Charleston, South Carolina

Printed in the United States of America

Library of Congress Catalog Card Number: 2007935546

For all general information contact Arcadia Publishing at:
Telephone 843-853-2070
Fax 843-853-0044
E-mail sales@arcadiapublishing.com
For customer service and orders:
Toll-Free 1-888-313-2665

Visit us on the Internet at www.arcadiapublishing.com

This book is dedicated to Mac Connery and Doug Walker, two friends whose generosity in sharing photographs, knowledge, and contacts with other railroad enthusiasts made the project possible.

CONTENTS

ACKNOWLEDGMENTS

I was very fortunate when Arcadia Publishing dropped my book proposal on editor Maggie Bullwinkel's desk. Without Maggie's patient guidance, I would not have this opportunity to thank the many people who made this book possible.

Doug Walker, Mac Connery, and Ken Marsh opened the doors to many of the photographers credited in this book. S. David Carriker not only loaned photographs but spent hours checking my text for accuracy. David's research of North Carolina's railroads is the benchmark by which others are judged, and that being said, any errors and omissions in this book are mine alone—our respective sources were sometimes at odds with each other. My thanks also to map expert Basil Watkins of Canterbury, England, for tracing many obscure lines.

Many of the vintage photographs in this book appear though the efforts of the following people: Michael Bickham of the Norfolk Southern Corporation; Zoe Rhine and Betsy Murray of Asheville's Pack Memorial Library; Kim Cumber and Vann Evans of the North Carolina Office of Archives and History; Beverly Tetterton of the New Hanover Public Library; Kurt Bell of the Railroad Museum of Pennsylvania; Thomas Mossbeck and Brent Lembert of the Kalmbach Memorial Library; and the Mohawk Chapter of the National Railway Historical Society's ALCO Historic Photos. C. Pat Cates, Dick Hillman, and Sallie Loy hosted my visits to the Southern Museum of Civil War and Locomotive History, which also houses the archives of the Southern Railway Historical Association. Mark Koenig of the Wilmington Railroad Museum and Edna Yates of the Chadbourn Depot Museum were equally generous in providing information, photographs, and time. My thanks also go to Ed Lewis of the Aberdeen and Rockfish; Carl Hollowell of the Aberdeen, Carolina, and Western; Ed Thum of the Kettle Falls International Railway; and Steve Head of the North Carolina Department of Transportation's rail division for providing answers to questions that had confounded months of searching. And finally, my heartfelt thanks to my wife, Susan, for her support and encouragement throughout the project.

INTRODUCTION

Four decades after its transition from a colony to a state, North Carolina exhibited scant improvements in economic and social development. Indeed, by 1830, the state seemed so resistant to the industrial and agricultural changes sweeping the rest of the country that it had acquired the nickname "the Rip Van Winkle State."

With few navigable rivers, most attempts to move people or goods across North Carolina in 1830 were limited to the speed of a horse or the even slower gait of oxen. Most of North Carolina's farmers were locked into subsistence farming, as it was folly to grow more perishable food than could be eaten at home or carried by wagon to the nearest town. The state's abysmal economy had limited the building of canals, the premier highways of the era, to lowland projects like the Dismal Swamp Canal.

In the fall of 1830, a revolutionary new form of transportation largely developed in England made a triumphant demonstration in neighboring South Carolina. "Railroads" married steam-powered, self-propelled machines known as "locomotives" to the rails and flanged-wheel carriages used by animal-propelled tramways. *The Best Friend of Charleston* pulled several carriages of passengers and freight on the rails of the South Carolina Canal and Railroad Company at speeds reaching 20 miles an hour: the pace of mankind had changed forever.

The success of the *Best Friend* sparked a great deal of interest but little progress in building the first railroad in North Carolina. Clearing and grading a right-of-way demanded an army of laborers; the state's economy offered little promise that a railroad, once built, could attract sufficient passenger and freight revenue to cover the daily costs of operation and maintenance. Not surprisingly, the first permanent railroad in North Carolina was opened in 1833 by comparatively well-heeled Virginians.

Despite volatile economic times, the steel rails grew. The Petersburg Railroad was joined by three new companies by the end of the decade. Despite emerging competition from timber-covered toll roads known as "plank roads," more than a dozen railroad companies were in operation in North Carolina by the end of the 1850s. A traveler could venture as far west as Morganton, and plans were afoot for Asheville and beyond. The Rip Van Winkle State was at least stirring, if not fully awake. The guns of Fort Sumter were to awaken it forever.

The Civil War took a terrible toll on North Carolina's railroads. All of its railroads were soon suffering from a shortage of rails, rolling stock, locomotives, and spare parts. In the final year of the conflict, both sides destroyed rail lines to further military objectives; Union forces operated captured portions of four railroads in the eastern part of the state. By war's end, North Carolina's railroads were in shambles.

The defeat of the Confederacy in 1865 marked a new beginning for railroads in North Carolina. Northern capital flowed in to help fund new roads. With the renewed and greatly expanded availability of railroad equipment, the iron horse had become a tool for business as well as commerce. Industrial railroads were built solely to serve logging and mining companies, creating new revenue traffic for mainline railroads.

By the 1920s, the railroad industry of North Carolina was the state's largest employer, and the citizens of nearly every town of consequence could board a train at the local depot for a journey to the destination of their choice. But as in the case of all enterprises, changes good and bad were to affect North Carolina's railroads. Few railroad lines escaped reorganizations and receiverships during their corporate lives. The growth of the paved highway system and automobiles closed some railroads and drove passenger trains to near-extinction within the next quarter-century.

In North Carolina, as in the rest of the nation, the railroad industry adapted and survived. In the 1980s, the number of railroads in North Carolina actually grew, as industry giants turned over the operation of their branch lines to new, smaller companies. At the dawn of the 21st century, more than 3,600 miles of tracks were still in active service in the state. In less than 30 years (or about the life span of a locomotive), North Carolina's railroads will celebrate their bicentennial, and what a party that should be.

One

The Common Carrier Railroad

This chapter will offer a glimpse of some of the common carrier railroads of North Carolina that have been listed in the official guides and railroad investment manuals over the past 174 years. An appendix lists additional railroads, albeit without photographs.

For those readers wondering what separates a "common carrier" railroad from one that isn't, common carrier railroads are those chartered to transport the public and/or goods for a fee; non–common carrier rail operations, such as quarry and logging roads, were closed to the general public.

A few words about this chapter: the parenthetical dates in each entry reflect the actual operating years of a company in North Carolina. In most cases only towns outside of North Carolina are identified by state.

Be wary of names when trying to identify a railroad. "Roanoke," in all but a few cases, refers to the river of that name in eastern North Carolina, rather than the city in Virginia. The Wilmington and Raleigh Railroad went to Weldon rather than Raleigh when it opened in 1840. Although the company finally got around to changing its name to the "Wilmington and Weldon Railroad" in 1855, more than a few writers since then have backdated the name change by neglecting to mention the original company name.

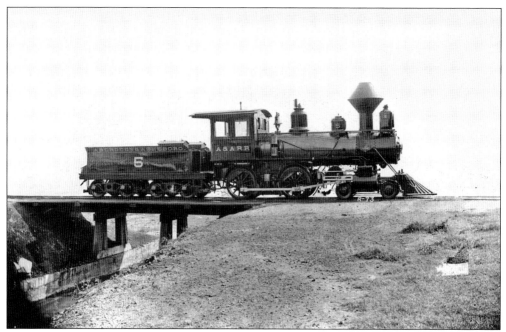

ABERDEEN AND ASHEBORO RAILROAD (1907–1912). The successor of the Aberdeen and Asheboro Railway, this company became part of the Norfolk Southern Railway's Raleigh, Charlotte, and Southern Railway in February 1912. (ALCO Historic Photos.)

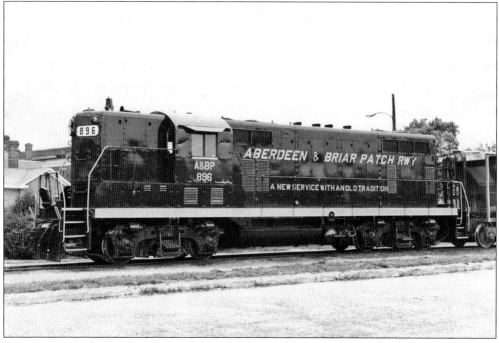

ABERDEEN AND BRIAR PATCH RAILROAD (1984–1987). Formed to take advantage of Norfolk Southern Corporation's divestment of some branchline operations, the Aberdeen and Briar Patch operated the 34.6-mile, ex–Norfolk Southern Railway line from Aberdeen to Star. The company was acquired by the Aberdeen, Carolina, and Western in June 1987. (Mac Connery.)

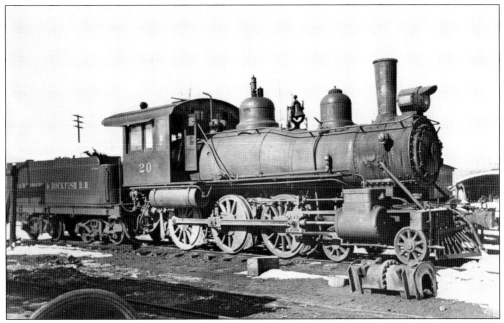

ABERDEEN AND ROCKFISH RAILROAD (1892–PRESENT). Established in June 1892 and still owned by the founding Blue family, the Aberdeen and Rockfish is the oldest family-owned railroad company in the state. The Aberdeen and Rockfish's current North Carolina operation consists of 46.9 miles of track from Aberdeen to Fayetteville. (Mac Connery collection.)

ABERDEEN AND WEST END RAILROAD (1889–1897). The Aberdeen and West End's standard-gauge line ran 25.33 miles from Aberdeen to Candor by 1893. The Aberdeen and West End merged with Asheboro and Montgomery to become the Aberdeen and Asheboro Railway on February 20, 1897. (S. David Carriker collection.)

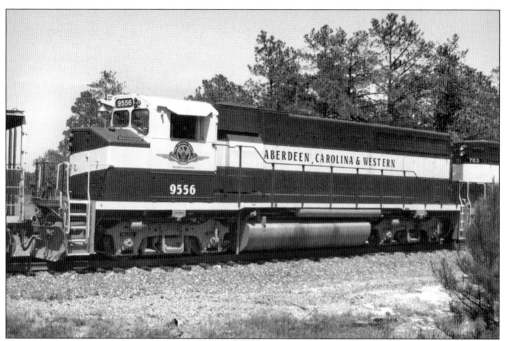

ABERDEEN, CAROLINA, AND WESTERN RAILWAY (1987–PRESENT). Two years after its purchase of the Aberdeen and Briar Patch Railroad, the Aberdeen, Carolina, and Western leased the former Norfolk Southern Railway Charlotte-to-Star line from the Norfolk Southern Corporation. The company currently operates 160 miles of track. (Bruce M. Hollar/Laura Holzbaur.)

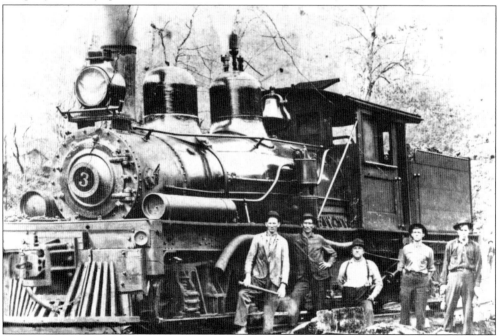

ALARKA VALLEY RAILWAY (1917–1923). The Alarka Valley was a 3-foot-gauge logging road that ran from Bryson City into its namesake valley. This 5-mile-long operation of the Alarka Lumber Company was abandoned in November 1923. (Jerry Ledford collection via Mac Connery.)

ALBEMARLE AND PANTEGO (A&P) RAILROAD (1887–1891). The A&P operated a 29.5-mile line from Mackey's Ferry to Belhaven with a 12-mile branch. The Albemarle and Pantego became part of the Norfolk and Southern Railroad on June 1, 1891. (Courtesy of the North Carolina State Archives.)

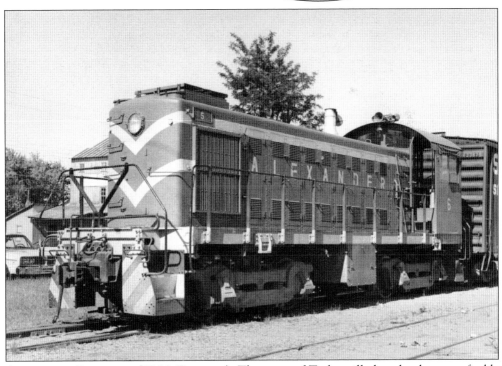

ALEXANDER RAILROAD (1946–PRESENT). The town of Taylorsville bought the unprofitable Taylorsville Branch (the former Statesville and Western) from the Southern for $50,350 on December 10, 1945. Under the leadership of Lawrence Zachary, the Alexander Railroad was organized and began operating the 18.5-mile line on February 7, 1946. The Zachary family continues to manage the Alexander's successful operations more than 60 years later. (Mac Connery.)

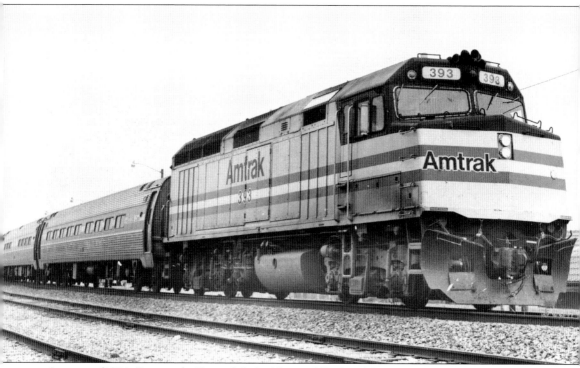

AMTRAK (1971–PRESENT). "Amtrak," the National Railroad Passenger Corporation, assumed operations of most of the nation's passenger service on May 1, 1971. In more recent years, Amtrak has operated the North Carolina Department of Transportation–sponsored *Piedmont* between Charlotte and Raleigh. (Mac Connery.)

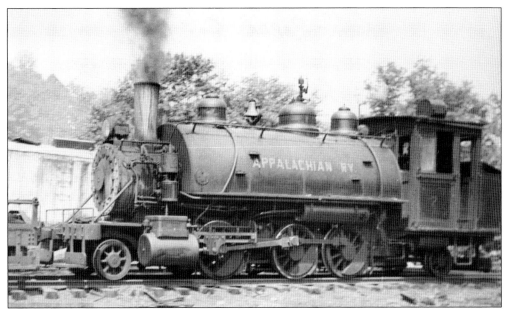

APPALACHIAN RAILWAY (1909–1935). The Appalachian Railway's 6.21-mile line from Ela on the Southern's Murphy Branch to Cherokee opened on June 14, 1909. The line was later extended four miles to Ravensford (Ocona Lufty). Although primarily a logging road, the Appalachian also carried passengers and provided a connection for the Ocona Lufty Railroad. Doomed by creation of the Great Smoky Mountains National Park, the company was gone by 1935. (Norman Williams; Mac Connery collection.)

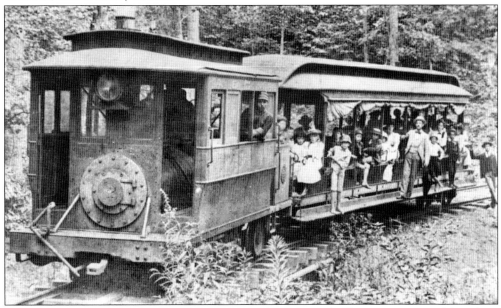

ASHEVILLE AND CRAGGY MOUNTAIN RAILWAY (1890–1906). This steam-powered line from Asheville to Golf Course was electrified in 1900 but returned to steam power for its 1.5-mile extension to Locust Gap in 1902. The company also operated the Asheville Southern Railway. The Asheville and Craggy Mountain was acquired by the Southern Railway in 1906. (Doug Walker collection.)

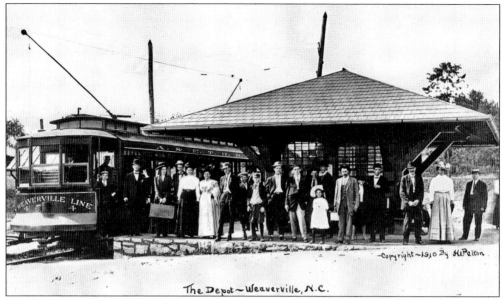

The Depot ~ Weaverville, N.C.

ASHEVILLE AND EASTERN TENNESSEE RAILROAD (1909–1922). The former Weaverville Electric Railway and Power Company, the Asheville and Eastern Tennessee Railroad offered more than 10 trips between Asheville from Weaverville at its peak. A 1922 accident on the line helped push the line into receivership, and the line shut down on November 29, 1922. (H. W. Pelton, Frank Moore collection.)

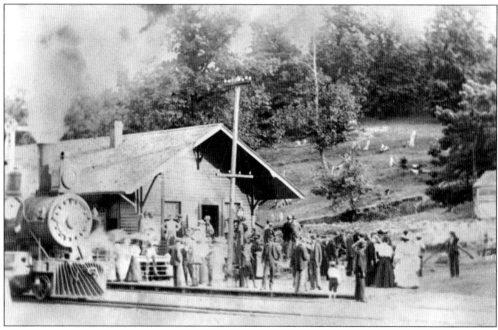

ASHEVILLE AND SPARTANBURG (A&S) RAILROAD (1881–1894). Successor to the Spartanburg and Asheville Railroad, the A&S reached Asheville from Hendersonville in 1886. Operated as part of the Richmond and Danville from 1881 until 1894, the company was acquired by the Southern Railway in 1894. (Southern Railway Historical Association Archives/Southern Museum of Civil War and Locomotive History [SRHA/SM].)

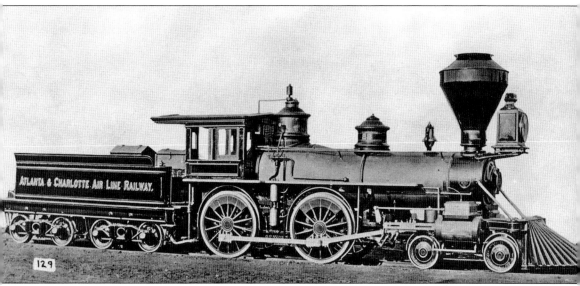

ATLANTA AND CHARLOTTE AIR LINE RAILROAD (1877–1894). Organized to take over the Atlanta and Richmond Air Line, the Atlanta and Charlotte Air Line had 40.6 of its 269 total miles in North Carolina. Leased by the Richmond and Danville in 1881, the road became part of the Southern in 1894. (SRHA/SM.)

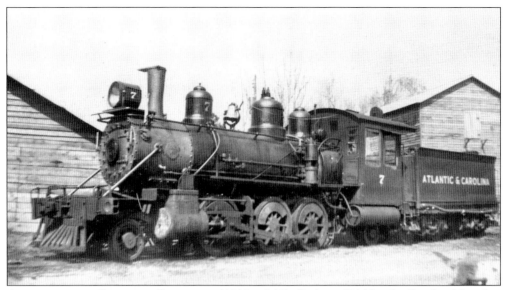

ATLANTIC AND CAROLINA RAILROAD (1915–1948). Built in 1914 by the Rowland Lumber Company, this 9.52-mile line running from Kenansville to Warsaw was sold to become the Atlantic and Carolina Railroad on April 10, 1915. The line was abandoned in March 1948. (Mac Connery collection.)

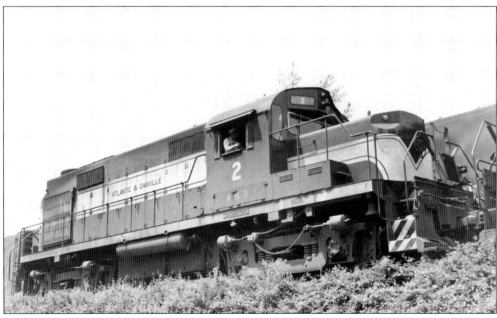

ATLANTIC AND DANVILLE RAILWAY (1890–1962). This 203-mile, Norfolk-to-Danville line meandered across the North Carolina/Virginia border to serve Semora, Milton, and Blanche. Foreclosed in 1894, the Atlantic and Danville (A&D) struggled along until 1899, when it was leased by the Southern Railway for 50 years. The Southern chose not to renew the lease in 1949, and the A&D operated as an independent road until it was purchased by the Norfolk and Western and reorganized as the Norfolk, Franklin, and Danville in 1962. (Mac Connery.)

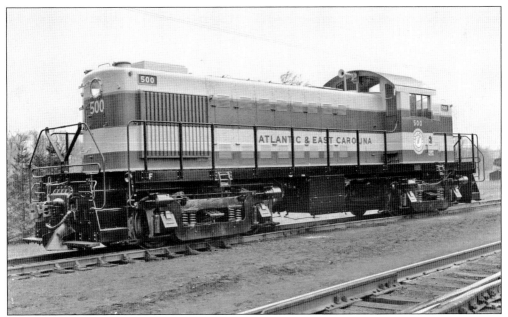

ATLANTIC AND EAST CAROLINA RAILWAY COMPANY (1939–1989). In addition to renaming the operating company of the Atlantic and North Carolina, lessor Harry Edwards rebuilt the nearly derelict line and its motive power. In 1957, the once-disdainful Southern Railway bought the Atlantic and East Carolina Railway and set it up as a subsidiary; the company still exists under the ownership of the Norfolk Southern Corporation. (ALCO Historic Photos.)

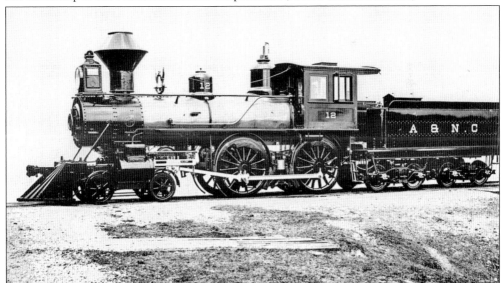

ATLANTIC AND NORTH CAROLINA RAILROAD (1858–1989). State-owned for its entire life, "the Mullet Line" was operated by the state from 1859 until 1904, when it was leased to the Norfolk Southern Railroad. After the Norfolk Southern failed to pay the rent in 1935, the state took over operations—again with notorious inefficiency. On September 1, 1939, the state leased the nearly derelict railroad to Harry P. Edwards, who operated the line as the Atlantic and East Carolina Railway. The state merged the Atlantic and North Carolina into the North Carolina Railroad in 1989. (ALCO Historic Photos.)

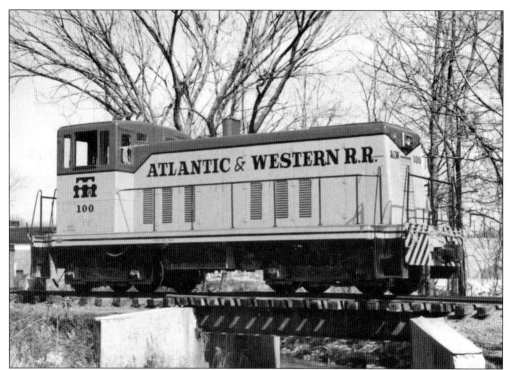

ATLANTIC AND WESTERN CORPORATION (1970–1988). Corporate successor to the Atlantic and Western Railway, the company was sold in 1988 to Rail Management Corporation, which reorganized it as the Atlantic and Western Railway Limited Partnership. (Mac Connery.)

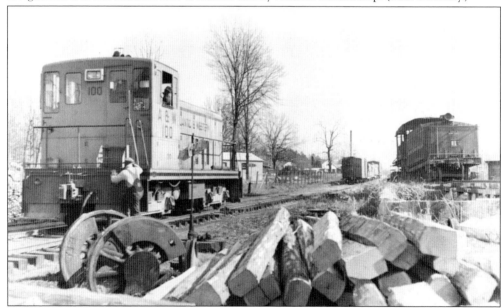

ATLANTIC AND WESTERN RAILWAY (1927–1970). Successor to the Atlantic and Western Railroad, this railway company abandoned all but its 3-mile, Sanford-to-Jonesboro track in 1961. In 1970, the company was merged into the Atlantic and Western Corporation. (Robert L. Drake, Doug Walker collection.)

ATLANTIC AND WESTERN (A&W) RAILWAY LP (1988–PRESENT). The successor to Atlantic and Western Corporation, new owner Rail Management Corporation added 9.3 miles of former Atlantic and Yadkin track (Sanford to Cumnock) to the A&W in the late 1990s. In 2005, Rail Management sold A&W Railway LP to the Genessee and Wyoming Corporation. (Felix Freeman, C. K. Marsh Jr. collection.)

ATLANTIC AND YADKIN RAILWAY (1899–1950). In 1899, the Southern bought the 130.95-mile, Mount Airy–to–Sanford line of the former Cape Fear and Yadkin Valley from the Wilmington and Weldon. Established as a separate company, the Atlantic and Yadkin Railway also included lines from Climax to Ramseur (18.74 miles), Stokesdale to Madison (11.38 miles), Greensboro to Proximity Mills (2.02 miles), and Gulf to Bluff Quarry (1.10 miles). The Atlantic and Yadkin was absorbed into the Winston-Salem Division of the Southern Railway in 1950. (SRHA/SM.)

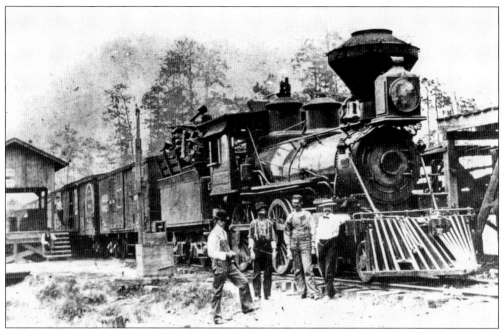

ATLANTIC COAST LINE RAILROAD (1900–1967). Based in Wilmington until 1960, the Atlantic Coast Line was second only to the Southern Railway in size in North Carolina, operating 1,054.37 miles of track by 1945. On July 1, 1967, the Atlantic Coast Line merged with longtime rival Seaboard Air Line Railroad. (Above, Frank Moore collection; below, Mac Connery.)

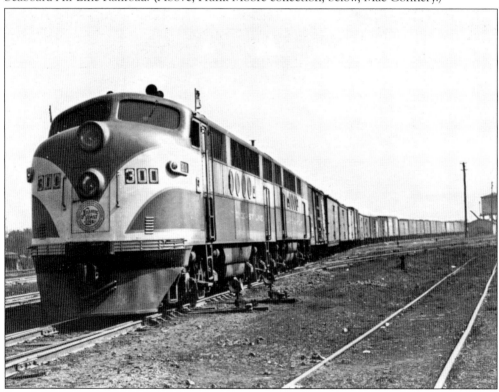

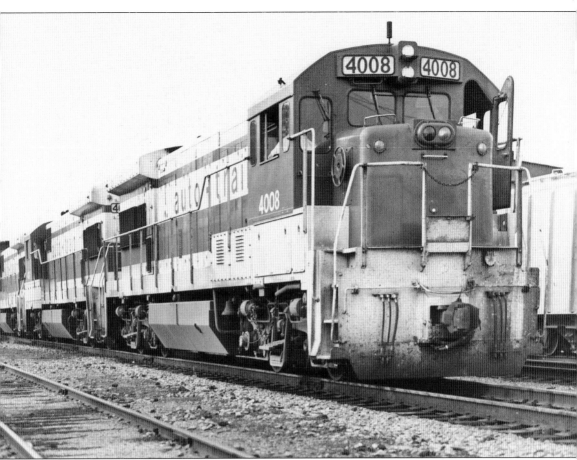

AUTO-TRAIN CORPORATION (1971–1981). Using an interesting collection of GE U-36B diesels, coaches, diners, sleeping cars, and double-deck automobile carriers, Auto-Train carried passengers and their vehicles between Lorton, Virginia, and Sanford, Florida. The merits of the idea outlived the unfortunate company: Amtrak resumed similar service two years after Auto-Train's 1981 failure. (Mac Connery.)

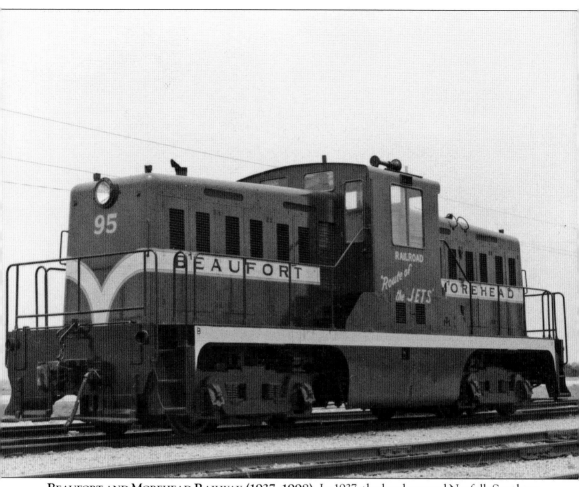

BEAUFORT AND MOREHEAD RAILWAY (1937–1998). In 1937, the hard-pressed Norfolk Southern Railway sold the former Beaufort and Western line to the new Beaufort and Morehead Railway. The North Carolina Ports Railway Commission bought the company in 1980 and used its name until 1998. (Mac Connery.)

BEE TREE RAILROAD (1905–1911). Owned by Bee Tree Lumber Company, the Bee Tree's standard-gauge logging line ran from Swannanoa to Wolf Branch. Sold on May 1, 1911, the line was renamed the Swannanoa Railroad. (Presbyterian Historical collection.)

BLACK MOUNTAIN RAILROAD (1910–1955). At the peak of its service, the 20-mile long Black Mountain ran from Kona to Eskota. Longtime owner Clinchfield sold the line in March 1955, at which time it became the Yancey Railroad. (Doug Walker collection.)

BONLEE AND WESTERN RAILROAD (1910–1932). The Bonlee and Western was an 11-mile line from Bonlee to Bennett. Though largely a timber-hauler, the Bonlee and Western offered passenger service until about 1927; freight operations ended with the line's abandonment on April 25, 1932. (Courtesy of the North Carolina State Archives.)

CALDWELL COUNTY RAILROAD (1994–PRESENT). Southeast Shortlines, Inc., operates the county-owned, ex–Carolina and Northwestern line from Hickory to Lenoir. The final 5-mile stretch at the Lenoir end of the 22.1-mile line was embargoed in 2007. (T. G. King, Marsh collection.)

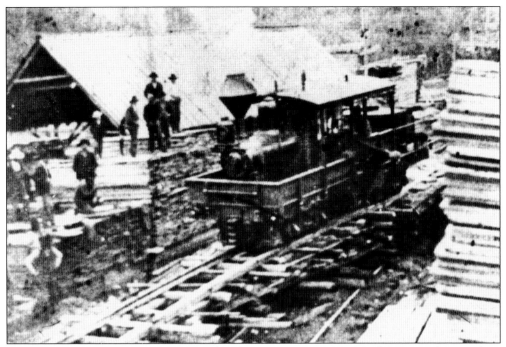

CANEY RIVER RAILWAY (1903–1909). The Caney River was a 3-foot-gauge logging line that ran 20 miles from the Clinchfield connection at Huntdale to Bald Mountain. (Jody Higgins collection.)

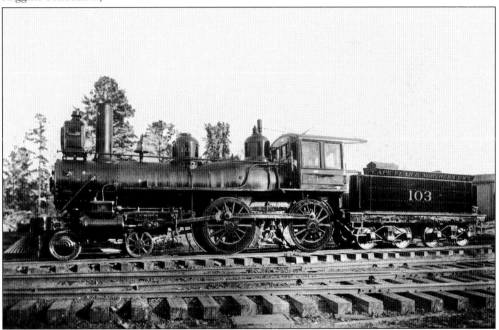

CAPE FEAR AND NORTHERN RAILWAY (1899–1906). Born as a logging railroad, the Cape Fear and Northern became a common carrier and ran 37.97 miles from Dunn to Apex. The company was reorganized as the Durham and Southern Railway on January 1, 1906. (C. W. Witbeck collection, via Mac Connery.)

CAPE FEAR AND YADKIN VALLEY RAILROAD (1879–1883). The Cape Fear and Yadkin Valley was formed by the merger of 47-mile Western Railroad of North Carolina and the graded right-of-way of the Mount Airy and Ore Knob Railroad. After four years of financial problems, the company was reorganized in 1883 as the Cape Fear and Yadkin Valley Railway. (Doug Walker collection.)

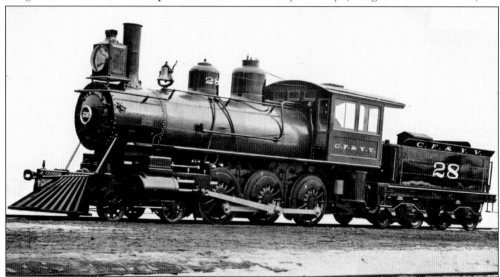

CAPE FEAR AND YADKIN VALLEY RAILWAY (1883–1899). The reorganized Cape Fear and Yadkin Valley (CF&YV) built a new line from Red Springs to Bennettsville, South Carolina, by 1884, and lines to Greensboro (1884), Mount Airy (1888), and Wilmington (1890). Peaking at 331.24 miles, the over-extended company was in receivership by 1894. After buying the CF&YV in 1899, the Wilmington and Weldon quickly resold the company to the Southern Railway, which in turn kept the tracks north of Sanford as the Atlantic and Yadkin and sold to lines south of Sanford back to the Wilmington and Weldon. (ALCO Historic Photos.)

CAPE FEAR RAILWAYS (1921–PRESENT). The successor to the Cumberland Railway and Power Company, Cape Fear Railways served Camp Bragg with a 9-mile line from a connection with the Aberdeen and Rockfish at Skibo and a second, 2-mile connection to the Atlantic Coast Line at Fort Junction by 1926. Service to Fort Bragg via a 2-mile connection to CSX is currently operated by the Kansas-based Seaboard Corporation. (Steam-era photograph, S. David Carriker collection; diesels, Mac Connery.)

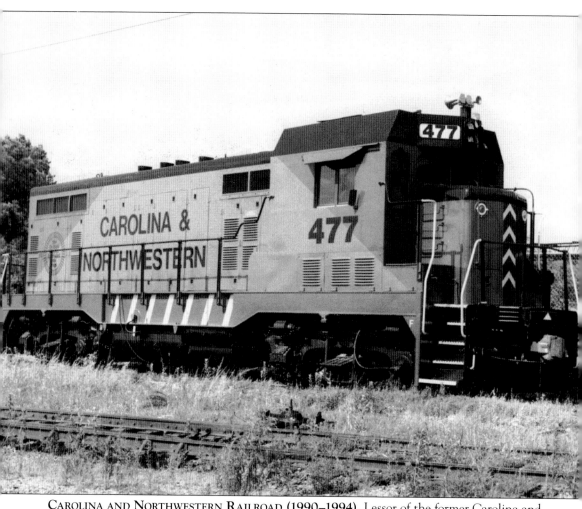

CAROLINA AND NORTHWESTERN RAILROAD (1990–1994). Lessor of the former Carolina and Northwestern line from Hickory to Lenoir, Rail Link's Carolina and Northwestern Railroad used a pair of CF-7 locomotives on the 22.1-mile route. After Rail Link chose to not renew its lease at the end of 1994, the Norfolk Southern sold the line to Caldwell County, which leased the line to the Caldwell County Railroad. (T. L. Sink, Marsh collection.)

CAROLINA AND NORTH-WESTERN RAILWAY (1897–1990). The reorganization of the Chester and Lenoir Narrow-Gauge Railroad, the Carolina and North-Western (C&N-W) was standard-gauged in 1902. The mainline ran 124.2 miles from Chester, South Carolina, to Edgemont. Over the years, declining revenues persuaded the independent Carolina and North-Western to become closely affiliated with the Southern Railway. In 1951, the Southern used the company name for a new subsidiary that included the Chester-to-Lenoir tracks (renamed the "Lenoir Division"), the Danville and Western, the Yadkin Railroad, and the High Point, Randleman, Asheboro, and Southern. In 1990, the Hickory-to-Lenoir segment of the old C&N-W was leased by the Norfolk Southern to Rail Link as the Carolina and Northwestern Railroad. (Above, John B. Allen collection; below, John D. Hahn, Mac Connery collection.)

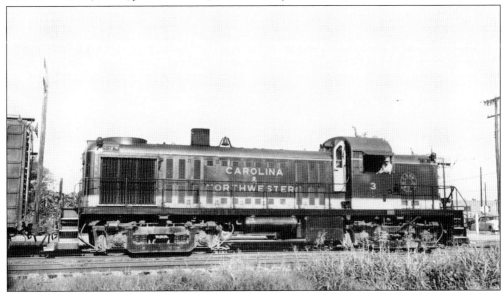

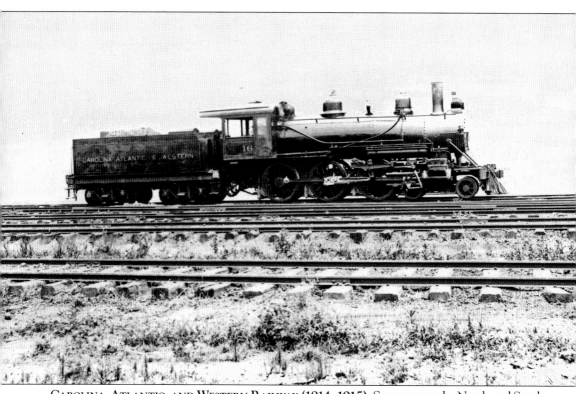

CAROLINA, ATLANTIC, AND WESTERN RAILWAY (1914–1915). Successor to the North and South Carolina Railway and the Georgetown and Western Railway, this company was in business for only a few months before being absorbed by the Seaboard Air Line in 1915. (Railroad Museum of Pennsylvania [PHMC], H. L. Broadbelt collection.)

CAROLINA CENTRAL RAILROAD (1880–1893). The former Carolina Central Railway, this company extended its tracks 27 miles from Shelby to Rutherfordton by March 1, 1887. The Carolina Central Railroad joined other roads under the Seaboard Airline Railway marketing banner in 1893; the lines officially merged as the Seaboard Airline Railway in 1900. (SRHA/SM.)

CAROLINA, CLINCHFIELD, AND OHIO RAILWAY (1908–1924). Successor to the South and Western Railroad, the "Clinchfield" reached Spartanburg, South Carolina, by 1919. The road's northern connection with the Chesapeake and Ohio at Elkhorn City, Kentucky, was completed in 1915. The Carolina, Clinchfield, and Ohio became the Clinchfield Railroad Company in 1924. (Marsh collection.)

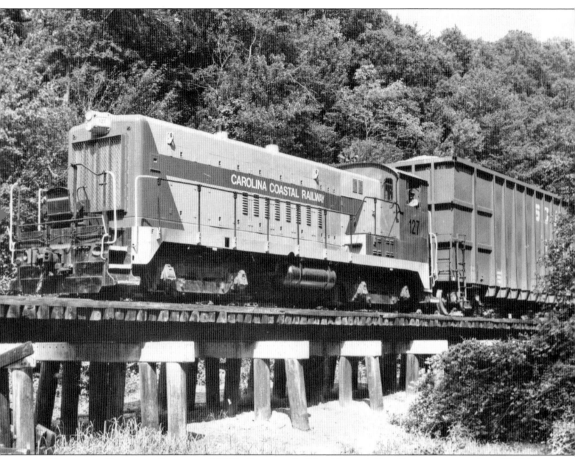

CAROLINA COASTAL RAILWAY (1989–PRESENT). The Coastal Carolina was created in 1989 by Rail Link to operate the 17-mile, ex-Norfolk Southern Railway line from Pinetown to Belhaven. The company was acquired by Main Line Rail Management Company in 2003; four years later, the Carolina Coastal added the 150-mile, Raleigh-to-Plymouth line originally built by the Norfolk Southern Railway. (Mac Connery.)

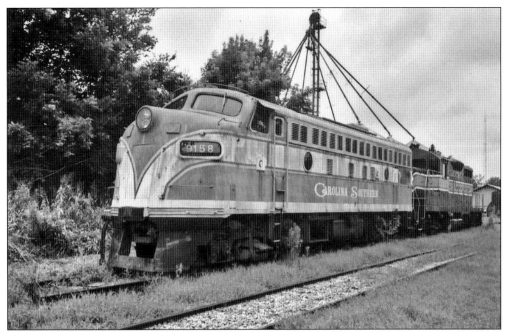

CAROLINA SOUTHERN RAILROAD (1995–PRESENT). Successor to the Mid-Atlantic Railroad as the operator of the ex-CSX line from Whiteville to Mullins, South Carolina, the Carolina Southern also operates the line from Chadbourn to Conway, South Carolina. (Phil and Karla Lafferty.)

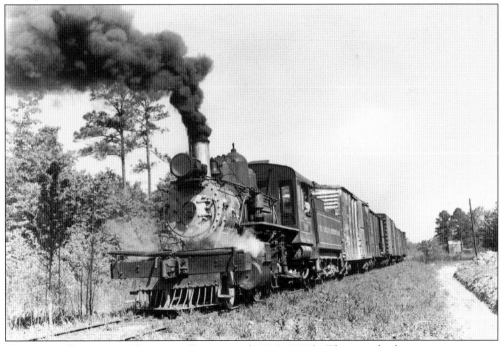

CAROLINA SOUTHERN RAILWAY COMPANY (1926–1961). The standard-gauge successor to Wellington and Powellsville's 3-foot-gauge short line between Ahoskie and Windsor, this 21.5-mile line was dieselized in 1951. The company abandoned operations on August 1, 1961. (John Krause, Marsh collection.)

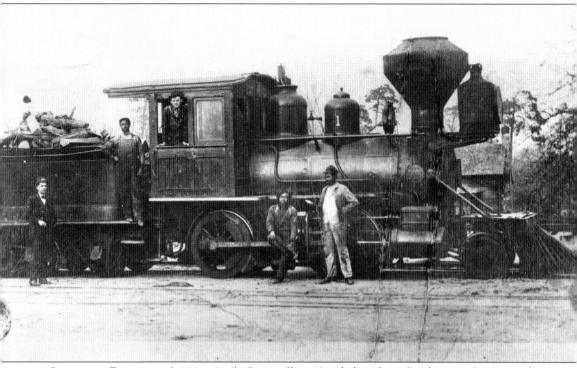

CARTHAGE RAILROAD (1888–1906). Originally a 10-mile line from Carthage to Cameron, the Carthage Railroad reached its 29.5-mile maximum length in 1898, at which time its Carthage and Western line was pulled up. The remaining 18.5-mile line from Cameron to Hallison (present-day Parkwood) became the Randolph and Cumberland Railroad in 1906. (Railroad House.)

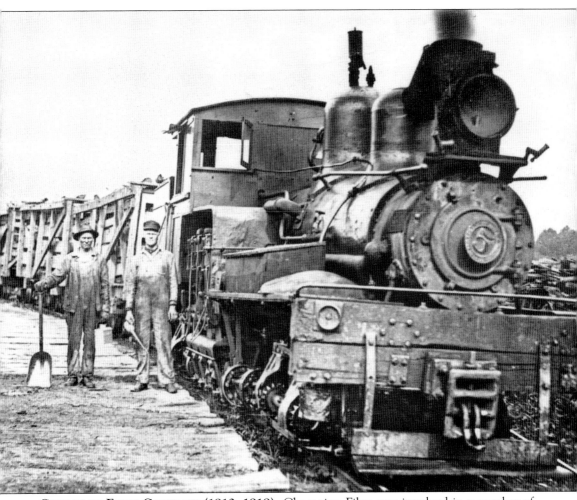

CHAMPION FIBRE COMPANY (1913–1919). Champion Fibre was involved in a number of railroad operations in Western North Carolina. Its narrow-gauge logging railroad inside the reservation of the Eastern Band of the Cherokee ran from Ravensford (present-day Ocona Lufty) to Smokemount and became the Ocona Lufty Railroad in September 1918. (Champion corporate archives via Jerry Ledford.)

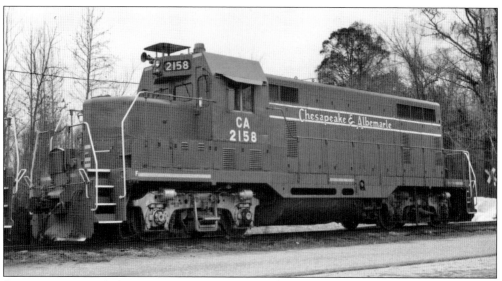

CHESAPEAKE AND ALBEMARLE RAILROAD (1990–PRESENT). A component of RailAmerica, the Chesapeake and Albemarle operates the 73-mile former Norfolk Southern line from Edenton to Norfolk under a "Thoroughbred Shortline Program" lease from the Norfolk Southern Corporation. The program turned the operation of many branch lines over to independent companies with lower operating costs. (Mac Connery.)

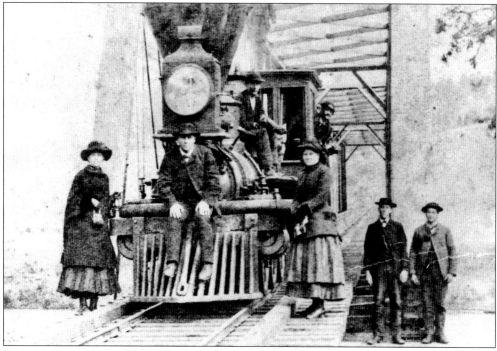

CHESTER AND LENOIR NARROW-GAUGE RAILROAD (1873–1897). Building upon the work of the Kings Mountain Railroad, this 3-foot-gauge railroad ran from Chester, South Carolina, to Lincolnton by 1880 and to Lenoir by 1884. Of its 109.5 miles, 10 were laid over the Western North Carolina Railroad by means of a third rail. The company was foreclosed and reorganized in 1897 as Carolina and North-Western Railway. (Doug Walker and Matthew Bumgarner collection.)

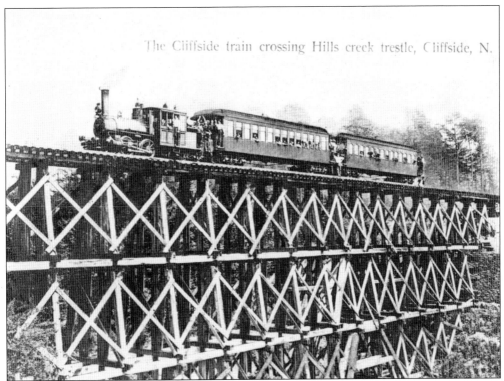

The Cliffside train crossing Hills creek trestle, Cliffside, N.

CLIFFSIDE RAILROAD (1905–1986). Owned by textile giant Cone Mills, the 3.86-mile Cliffside connected Matheney, Avondale, Cliffside, and West Henrietta to the Seaboard Air Line and its successors at Cliffside Junction. (Above, Doug Walker collection; below, Mac Connery.)

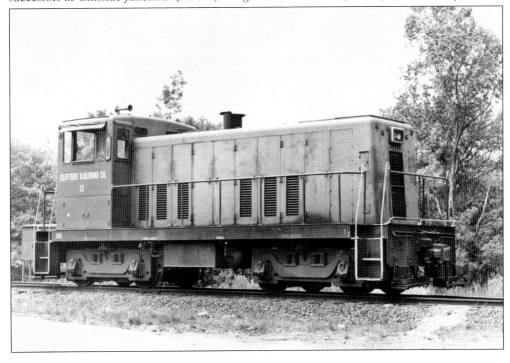

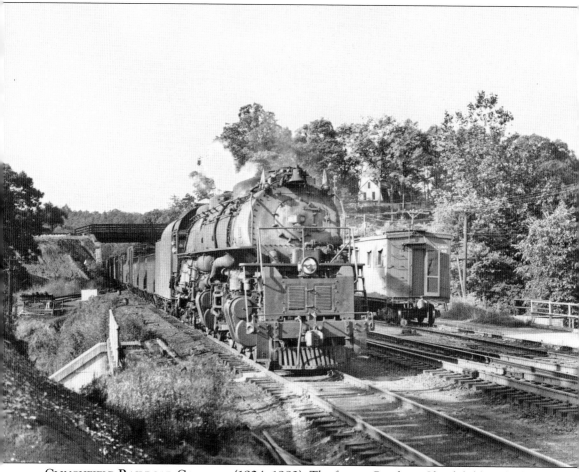

CLINCHFIELD RAILROAD COMPANY (1924–1983). The former Carolina, Clinchfield, and Ohio Railway, the Clinchfield's mainline ran from Elkhorn, Kentucky, to Spartanburg, South Carolina, and 42 percent of the track lay within North Carolina. Leased to Atlantic Coast Line and the Louisville and Nashville in 1925, the Clinchfield operated as an independent road until it became part of Seaboard System in 1983. (David Driscoll, Tom Wicker collection.)

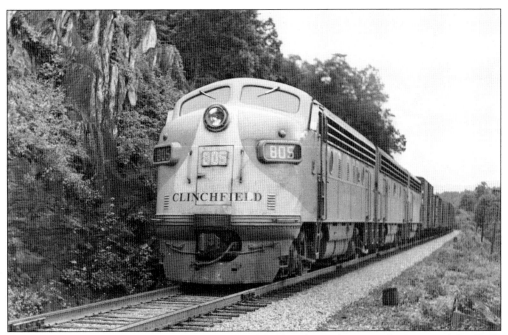

CLINCHFIELD RAILROAD COMPANY. The Clinchfield so favored F-units that a pair of the EMD diesels appeared on its company logo for many years. (R. B. Carneal, Marsh collection.)

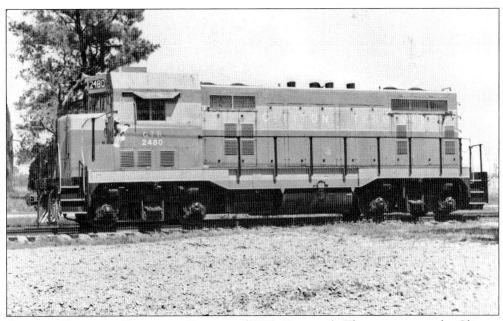

CLINTON TERMINAL RAILROAD COMPANY (1995–PRESENT). The successor to the Clinton Division of the Waccamaw Coastline, this 3.5-mile switching road connects with the CSX in its namesake town. (T. G. King, Marsh collection.)

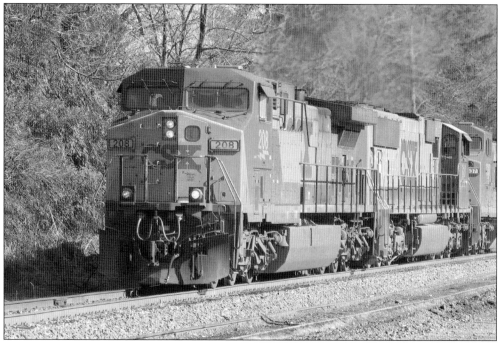

CSX Transportation (1986–Present). The successor to Seaboard System, CSX Transportation currently operates the North Carolina routes inherited from the Clinchfield, Seaboard Airline, and the Atlantic Coast Line, as well as their respective predecessor railroads. (Alan Coleman.)

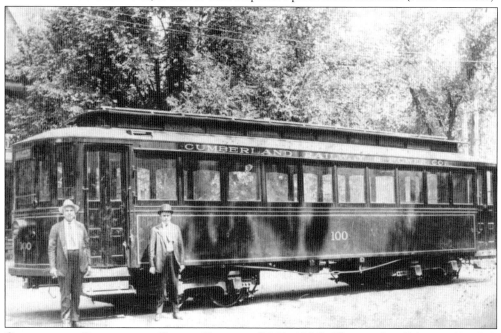

Cumberland Railway and Power Company (1919–1921). Chartered on February 12, 1919, to operate Fayetteville's trolley system, this cash-poor line was sold for $75,000 on August 2, 1921. The new owner, North State Power Company, quickly conveyed operations (but not ownership) of the line to the newly formed Cape Fear Railways. (S. David Carriker collection.)

DANVILLE AND WESTERN RAILWAY (1899–1951). The Danville and Western standard-gauged the Danville, Mocksville, and Southwestern Railroad's 8-mile branch from Leaksville Junction, Virginia, to the North Carolina town of Leaksville (now part of Eden). In 1951, its remaining mileage was leased and operated as the Carolina and North-Western's Martinsville Division. (Above, Mac Connery collection; below, ALCO Historic Photos.)

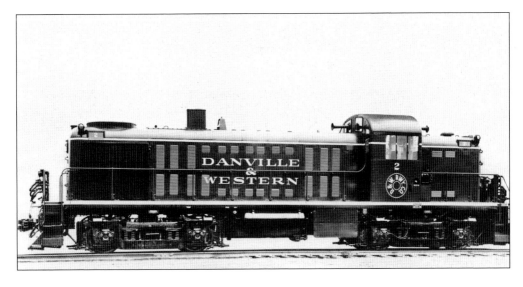

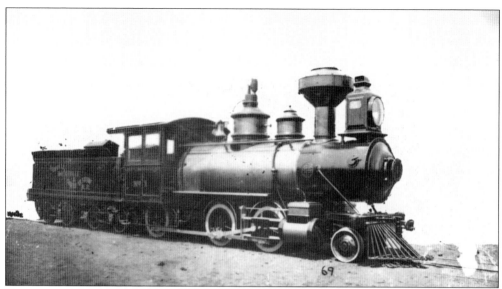

DANVILLE, MOCKSVILLE, AND SOUTHWESTERN RAILROAD (1882–1899). The Danville, Mocksville, and Southwestern was established to extend Virginia's Danville and New River Railroad into North Carolina. The line was acquired and standard-gauged by the Danville and Western Railway Company in 1899. (PHMC, H. L. Broadbelt collection.)

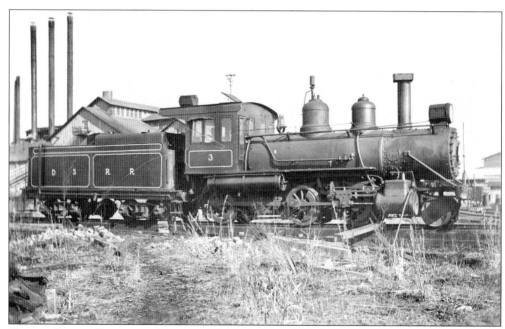

DISMAL SWAMP RAILROAD (1896–1941). Known to the Interstate Commerce Commission as the Richmond Cedar Works Railroad but commonly known by the Dismal Swamp Railroad name painted on its equipment, this 35-mile, 42-inch-gauge logging road operated across the North Carolina/Virginia border until 1941. (SRHA/SM.)

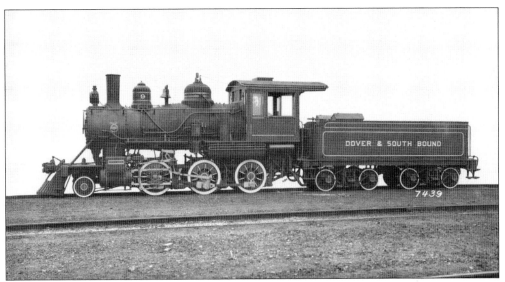

DOVER AND SOUTH BOUND RAILROAD (1906–1930). With ancestry as a Goldsboro Lumber Company logging line, this 24.6-mile common carrier line ran from Dover to Richland. The Dover and South Bound was sold to back to the Goldsboro Lumber Company in 1930. (PHMC, H. L. Broadbelt Collection.)

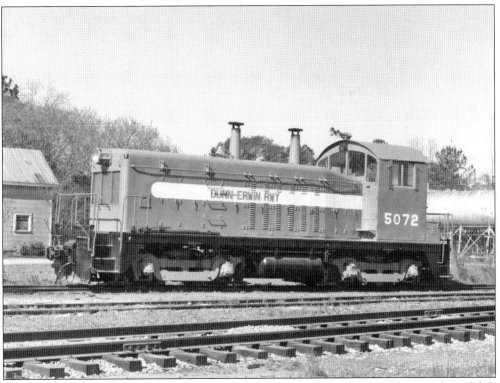

DUNN-ERWIN RAILROAD (1987–1999). Founded in 1987 by the Aberdeen and Rockfish Railroad, the Dunn-Erwin served customers on the first 1.4 miles of CSX's former Durham and Southern line. The last revenue car was handled by the Dunn-Erwin on July 31, 1999, and the line's abandonment was effective the following day. (Mac Connery.)

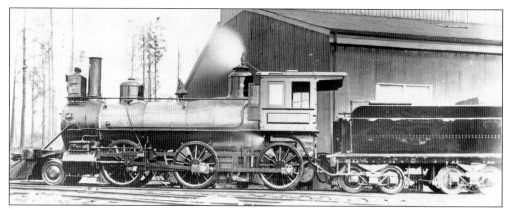

DURHAM AND SOUTH CAROLINA RAILROAD (1905–1920). This 42-mile line from Duncan to East Durham was leased by the Norfolk Southern in 1920. In 1925, the Norfolk Southern built a line into Durham to compete with the Norfolk and Western for American Tobacco Company traffic. The Durham and South Carolina was purchased outright by the Norfolk Southern in 1957. (John B. Allen, Mac Connery collection.)

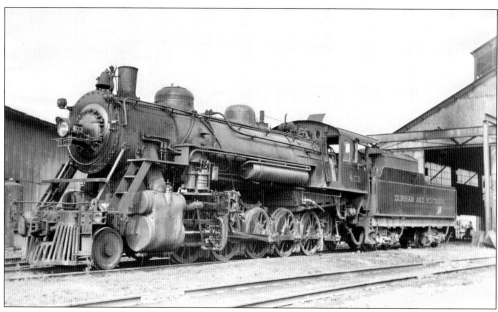

DURHAM AND SOUTHERN RAILWAY (1906–1976). Successor to the Cape Fear and Northern Railway, this James B. Duke–owned road ran from Durham to connections with the Seaboard Air Line at Apex and the Atlantic Coast Line in Dunn. Operated under joint management with Duke's Piedmont and Northern from 1931 to 1954, the 58.57-mile line was sold to local Durham interests in 1954. Bought by the Seaboard Coast Line in 1976, its name and much of its track was gone by 1981. (Wiley M. Bryan, Tom L. Sink collection.)

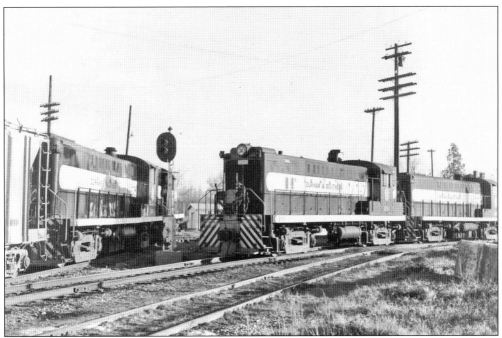

DURHAM AND SOUTHERN RAILROAD. The Durham and Southern was noted for its long preference for Baldwin diesels. (Warren Calloway, Mac Connery collection.)

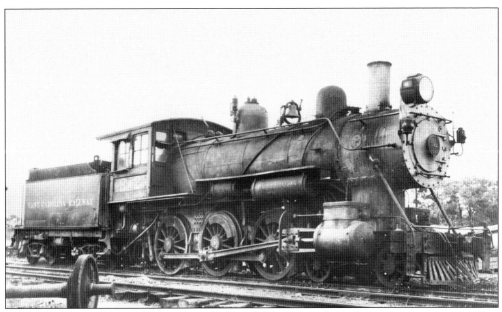

EAST CAROLINA RAILWAY (1898–1965). Founded by Henry L. Bridgers, the narrow-gauge East Carolina Railway was purchased by the Wilmington and Weldon Railroad on May 23, 1899, and leased back to Bridgers. The line was standard-gauged and lengthened to become a 25.6-mile route from Tarboro to Farmville by 1901; an expensive, 12-mile extension to Hookerton opened in March 1908. Atlantic Coast Line took over operations on January 1, 1935, and supported the East Carolina until its last run on November 16, 1965. (Tom G. King collection.)

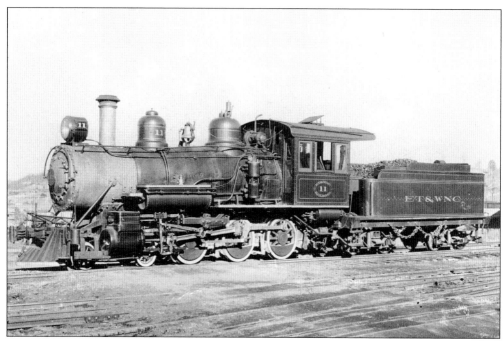

EAST TENNESSEE AND WESTERN NORTH CAROLINA RAILROAD (1882–1950). This famed 34.85-mile, 3-foot-gauge line opened from Johnson City, Tennessee, to Cranberry on July 3, 1882. The last of its narrow-gauge operations in North Carolina occurred on October 16, 1950. (SRHA/SM.)

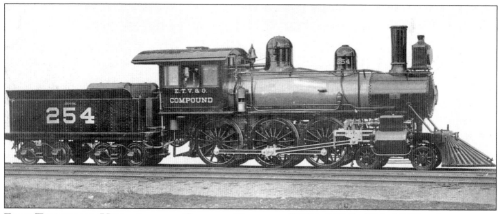

EAST TENNESSEE, VIRGINIA, AND GEORGIA RAILWAY (1886–1894). This 1,200-mile successor to the railroad of the same name was controlled by the Richmond and West Point Terminal Railway and Warehouse Company before becoming part of the Southern Railway in 1894. (SRHA/SM.)

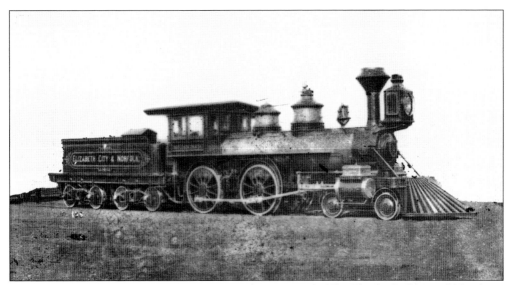

ELIZABETH CITY AND NORFOLK RAILROAD (1881–1883). The Elizabeth City and Northern built and operated 73 miles of track between Edenton and Berkeley, Virginia. The company was sold and renamed as the Norfolk and Southern Railroad in January 1883. (PHMC, H. L. Broadbelt collection.)

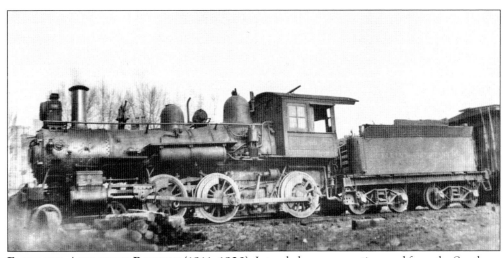

ELKIN AND ALLEGHENY RAILWAY (1911–1920). Intended as a connecting road from the Southern at Elkin to the Norfolk and Western in Ashe County, the Elkin and Allegheny only reached 15 miles from Elkin to Veneer, an end-of-the-line station one mile north of Doughton. Sold at a receiver's sale on October 7, 1919, the line became the Elkin and Allegheny Railroad on January 31, 1920. (Doug Walker collection.)

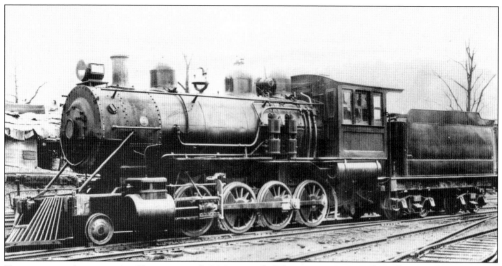

ELKIN AND ALLEGHENY RAILROAD (1920–1931). The successor to the Elkin and Allegheny Railway, the company was doomed by the completion of U.S. Highway 21. The Elkin and Allegheny got permission to abandon the line in July 1931. (John. B. Allen collection.)

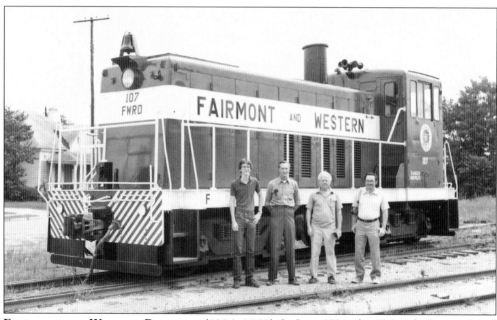

FAIRMONT AND WESTERN RAILROAD (1984–1988). In June 1984, the 12.8-mile Fairmont and Western became the first of L&S Holding Company's sister operations to the Laurinburg and Southern. Unfortunately CSX's wisdom in shedding the former Atlantic Coast Line track from Elrod to Fairmont was evident within four years. The Fairmont and Western was closed in 1988 and pulled up for scrap in 1989. (Mac Connery collection.)

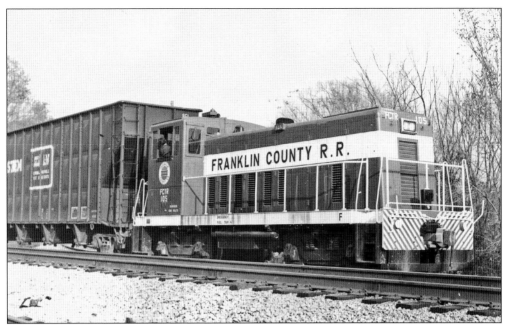

FRANKLIN COUNTY RAILROAD (1985–1988). This former Louisburg Railroad/Atlantic Coast Line/Seaboard System branch was operated by L&S Holding Company for three years before lack of revenue traffic on the 10-mile line resulted in its abandonment in 1988. (Mac Connery.)

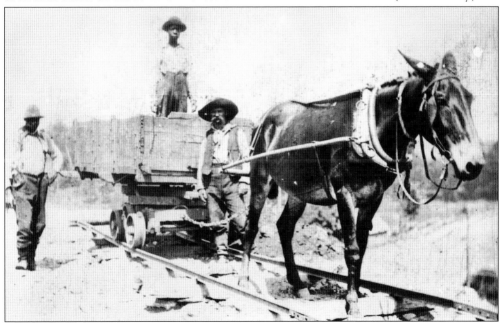

GEORGIA, CAROLINA, AND NORTHERN RAILWAY (1888–1900). Before running its first train (which is the time frame of the photograph), the Georgia, Carolina, and Northern was leased for life by the Seaboard and Roanoke and the Raleigh and Gaston railroads. With only 15 of its 268 miles of tracks in North Carolina (Monroe to the South Carolina border via Waxhaw), the Georgia, Carolina, and Northern became the Atlanta Division of the Seaboard Air Line in 1900. (Jim Harris collection.)

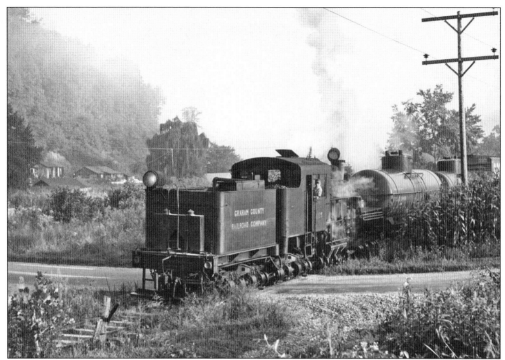

GRAHAM COUNTY RAILROAD (1925–1970, 1974–1975, 1982–1985). Famed for its Shay steam operations into the 1970s, this 12-mile line ran from Graham County Junction (near Topton) to Robbinsville. The Graham County sporadically operated the Bear Creek Scenic Railroad tourist line from 1966 until 1975. Frequent floods and lack of traffic finally killed the by-then-dieselized line in 1985; its rails were removed two years later. (Above, Richard D. Kehm; below, Mac Connery.)

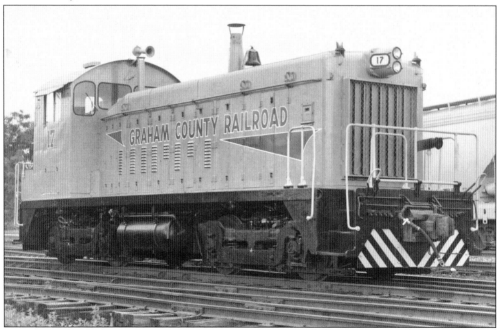

HEMLOCK RAILROAD (1912–1914). An Ashe County 3-foot-gauge common carrier owned by the Damascus Lumber Company, the Hemlock ran six miles from the community of Hemlock to Millekoo. The line was abandoned by 1915, and its leased rails were pulled up and returned to the Norfolk and Western. (Ashe County Historical Society.)

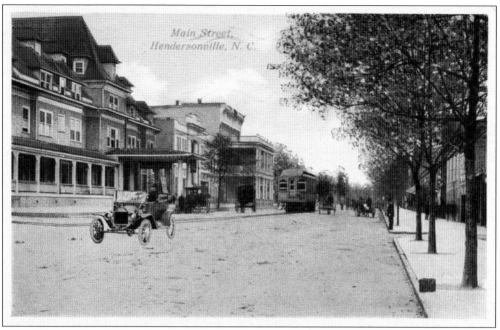

HENDERSONVILLE TRACTION COMPANY (1912–1918). Successor to the Appalachian Interurban, the Hendersonville Traction's storage battery car never matched the image created by this postcard artist. In 1918, the tracks were replaced by Model T automobile service for two more years. (Alan Coleman collection.)

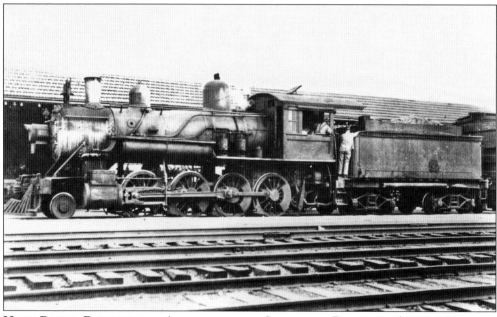

HIGH POINT, RANDLEMAN, ASHEBORO, AND SOUTHERN RAILROAD (1889–1894 AND 1916–1951). A 27-mile route built by the Richmond and Danville, the line was absorbed into the Southern in 1894. The company regained its independence from July 1916 until 1951, when it became the Asheboro Division of the Carolina and North-Western. (Paul Parrish, Mac Connery collection.)

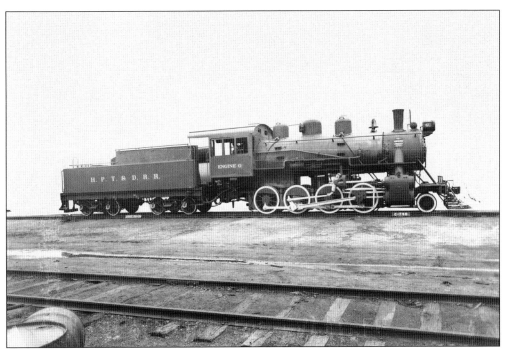

HIGH POINT, THOMASVILLE, AND DENTON RAILROAD (1924–PRESENT). Successor to the Carolina and Yadkin River Railway, the High Point, Thomasville, and Denton operates a 34-mile line from High Point to High Rock. In 1960, the road became an independent subsidiary of the Winston-Salem Southbound Railway. (Above, ALCO Historic Photos; below, Bob Drake, Mac Connery collection.)

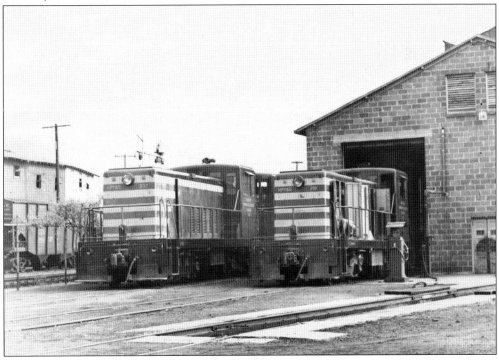

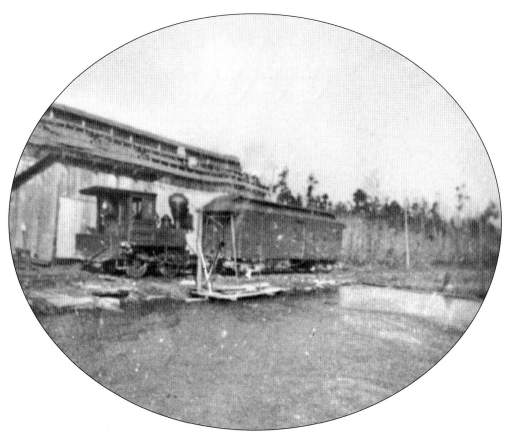

JAMESVILLE AND WASHINGTON RAILROAD OF NORTH CAROLINA (1877–1882 AND 1884–1896). The Jamesville and Washington offered off-and-on service on its six miles of rails from Washington to Cherry Mills until its abandonment in 1896. (Capt. Henry C. Bridgers Collection, Joyner Library, East Carolina University.)

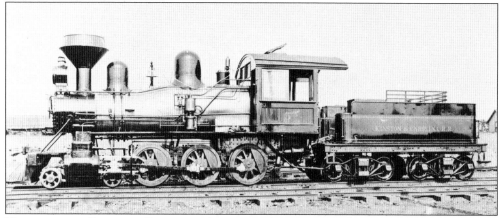

KINSTON AND CAROLINA RAILROAD (1901–1909). Incorporated on December 28, 1901, the Kinston and Carolina primarily hauled lumber on its 22-mile line from Kinston to Pink Hill. On October 29, 1909, the Kinston Lumber Company and its railroad were purchased by the Norfolk Southern Railroad at a foreclosure sale. The railroad underwent a minor name change to become the Kinston-Carolina Railroad in early 1910. (Mac Connery collection.)

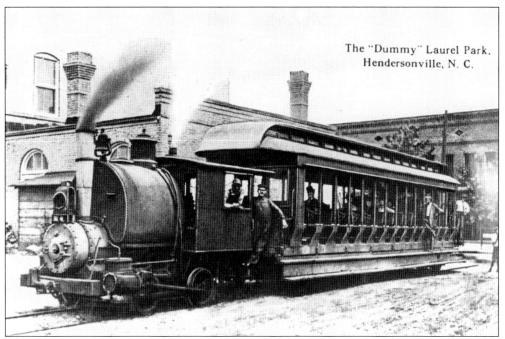

LAUREL PARK STREET RAILWAY (1905–1916). The Laurel Park was a summer-only operation, running 1.5 miles from Hendersonville's Main Street to Rainbow Lake. (Mac Connery collection.)

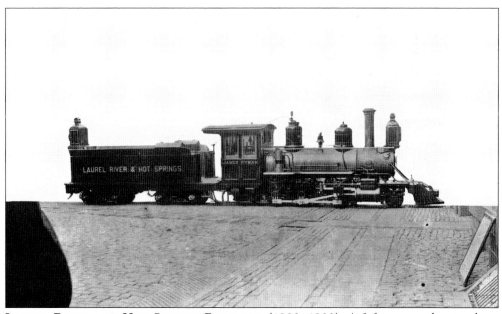

LAUREL RIVER AND HOT SPRINGS RAILROAD (1892–1893). A 2-foot-gauge logging line, the Laurel River and Hot Springs only managed to build 2.5 miles of track out of Hot Springs towards Laurelton before being caught up and closed by the Panic of 1893. (PHMC, H. L. Broadbelt collection.)

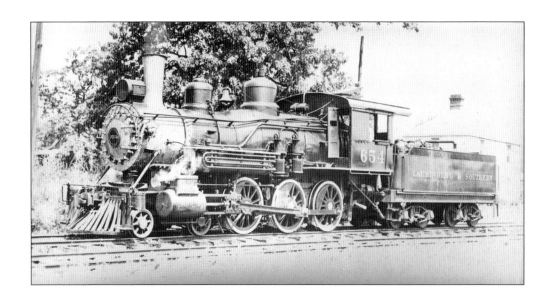

LAURINBURG AND SOUTHERN RAILROAD (1909–PRESENT). Operating from Johns to Laurinburg, the 28-mile Laurinburg and Southern was owned for four generations by the Evans family until its 1994 sale to Gulf and Ohio Railways. (Above, Tom King collection; below, Warren Calloway.)

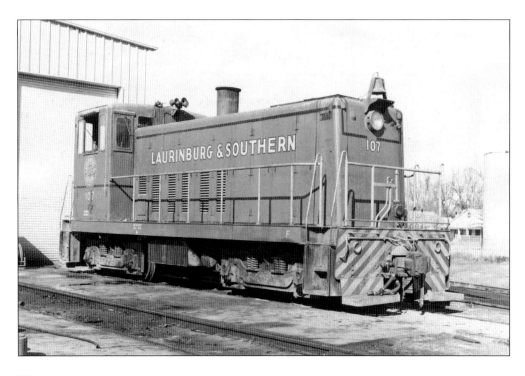

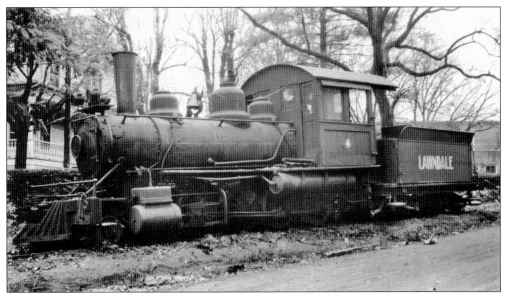

LAWNDALE RAILWAY AND INDUSTRIAL COMPANY (1899–1941). The Lawndale operated an 8-mile, narrow-gauge line from a connection with the Seaboard Air Line just west of Shelby at Lawndale Junction to its owner's textile mill at Lawndale. The 3-foot-gauge Lawndale's last run occurred on April 30, 1943. (Kalmbach Memorial Library.)

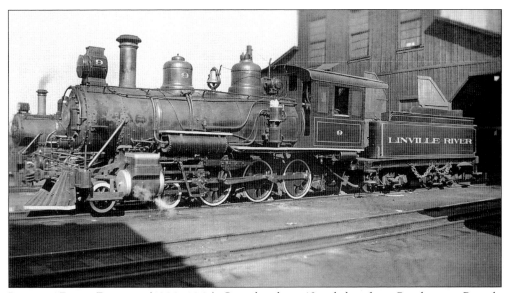

LINVILLE RIVER RAILWAY (1899–1941). Completed as a 12-mile line from Cranberry to Pineola in 1899, the Linville River Railway was operated by the W. M. Ritter Company until 1913, when it sold the line to the Cranberry Iron and Coal, parent of the East Tennessee and Western North Carolina Railroad (ET&WNC). The Linville River Railway served as a subsidiary of ET&WNC and completed a 20-mile line north from Pineola to Boone in 1918. The Linville River Railway was closed by flood damage in 1940 and was formally abandoned in March 1941. (SRHA/SM.)

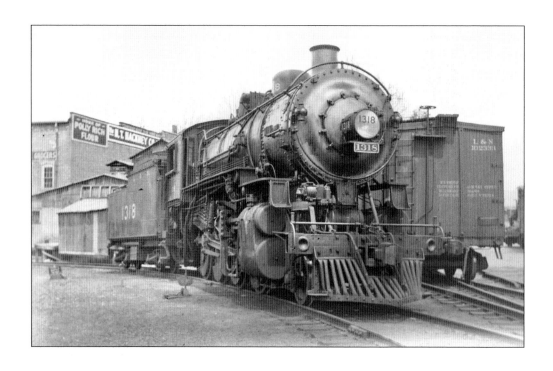

LOUISVILLE AND NASHVILLE RAILROAD (1902–1982). A minor presence in North Carolina, the Louisville and Nashville came to the state via its 1902 purchase of the Atlanta, Knoxville, and Northern Railway and its branch from Marietta, Georgia, to Murphy. (Above, Norman Williams, Marsh collection; below, ALCO Historic Photos.)

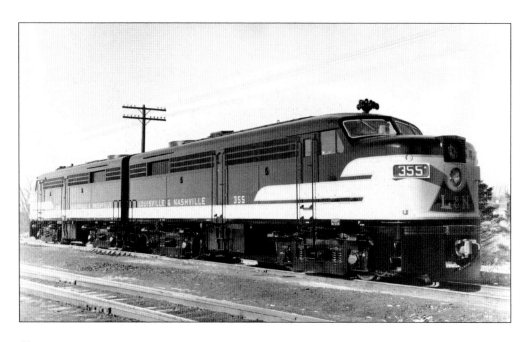

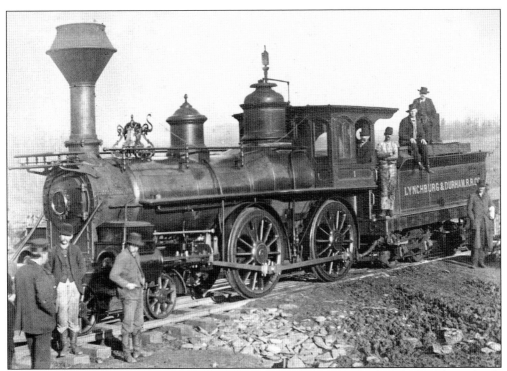

LYNCHBURG AND DURHAM RAILROAD (1890–1896). Opened on September 15, 1890, this 115-mile line was leased to Norfolk and Western Railroad (N&W) on March 11, 1892. In September 1896, the N&W bought the Lynchburg and Durham (L&D) and renamed the line as its Durham Division. Most of the old L&D line was abandoned in the 1980s. (Norfolk Southern Corporation.)

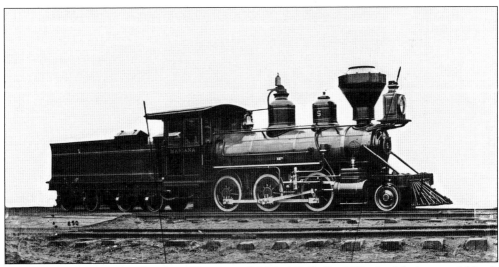

MARIETTA AND NORTH GEORGIA RAILWAY (1890–1896). By 1893, the Marietta and North Georgia ran from Marietta, Georgia, to the Hiwassee River at Murphy. Due to right-of-way disputes, freight and passengers desiring to ride the Murphy Branch to Asheville had to be ferried across the river to make their connection. The Marietta and North Georgia was purchased by the Atlanta, Knoxville, and Northern Railway in 1896. (PHMC, H. L. Broadbelt collection.)

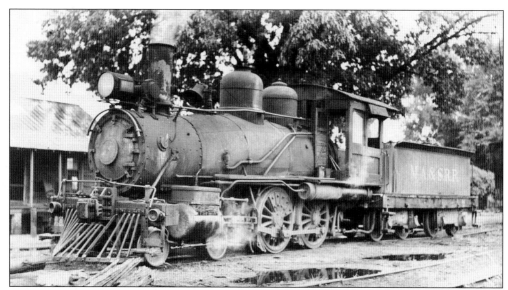

MAXTON, ALMA, AND SOUTHBOUND RAILROAD (1911–1937). The June 1, 1911, successor to the Alma Lumber Company railroad, the Maxton, Alma, and Southbound extended the line to Rowland. This railroad made its last run in August 1937. (Tom G. King collection.)

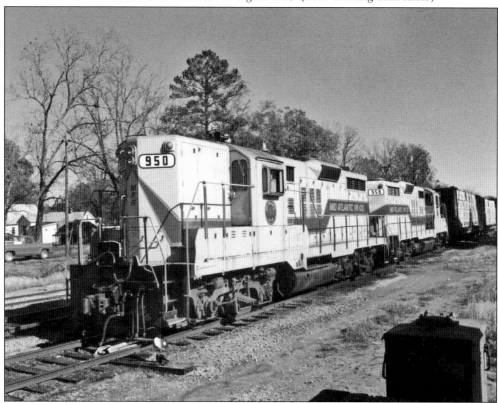

MID ATLANTIC RAILROAD (1987–1995). Formerly Duval Transportation, the Mid Atlantic Railroad operated the ex-CSX line from Mullins, South Carolina, to Whiteville. The Mid Atlantic was purchased to become the Carolina Southern Railroad in February 1995. (Mac Connery.)

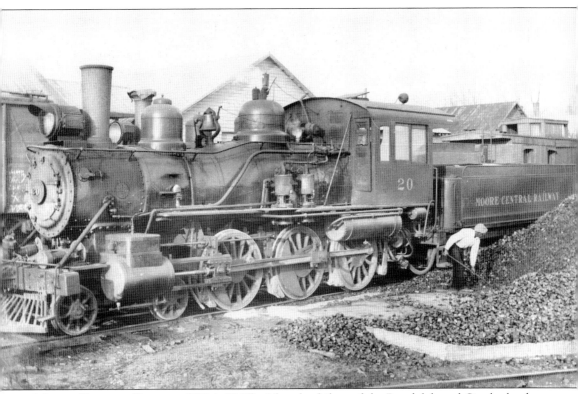

MOORE CENTRAL RAILWAY (1924–1945). After the failure of the Randolph and Cumberland Railway, the town of Carthage got permission from the state legislature for the town to buy the line and abandon a 2-mile segment. The remaining line failed to be profitable; by 1944, the line was in receivership. The Moore Central Railway was sold to the Carthage Weaving Company to become the Moore Central Railroad in 1945. (Doug Walker collection.)

MOORE COUNTY RAILROAD (1893–1904). The sister company to the Aberdeen Forwarding Company, this 12.5-mile-long, standard-gauge logging road ran from Aberdeen to the lumber village of Craigrownie by 1900. When corporate suitor "Moore County and Western Railroad" turned out to be a fraud, the Moore County's future was doomed. The line was abandoned in February 1904. (Mallory H. Ferrell collection.)

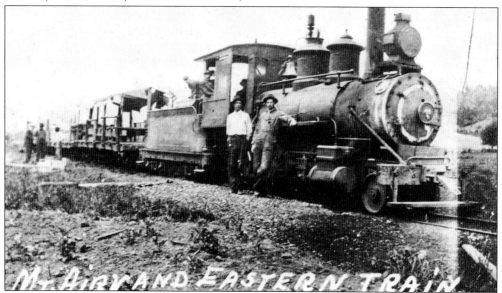

MOUNT AIRY AND EASTERN RAILROAD (1900–1918). The first 15.75 miles of this 3-foot-gauge line from Mount Airy to Goings, Virginia, opened on February 1, 1900. The line was extended an additional 3.5 miles to Kibler, Virginia, by November 1, 1902. Known by the locals as the "Dinky Railroad," only 5 of its 19.5 miles of track were in North Carolina. Abandoned in 1918, efforts to revive the line in 1920 as the Virginia and Mount Airy Railroad were unsuccessful. (Doug Walker collection.)

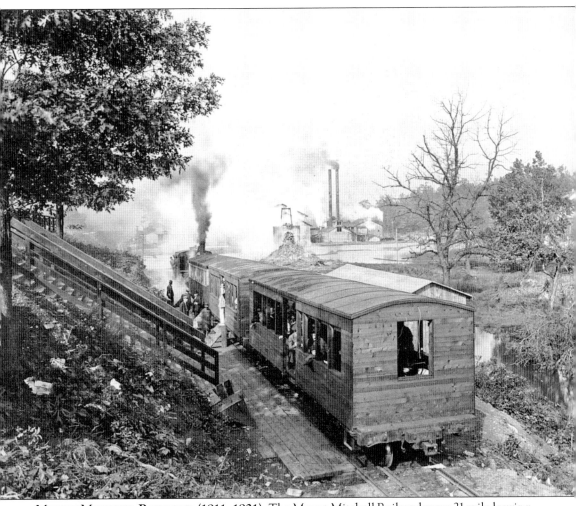

Mount Mitchell Railroad (1911–1921). The Mount Mitchell Railroad was a 21-mile logging road from a mill near Black Mountain to within hiking distance of North Carolina's highest peak. The Mount Mitchell Railroad offered seasonal excursion service from 1913 until 1918, when wartime pressures for aircraft spruce closed its "Mount Mitchell Scenic Railroad" on August 22. Owner Perley and Crockett Lumber Company was unsuccessful in reinstating passenger service, and the line was closed in 1921. (William A. Barnhill Collection, Pack Memorial Library.)

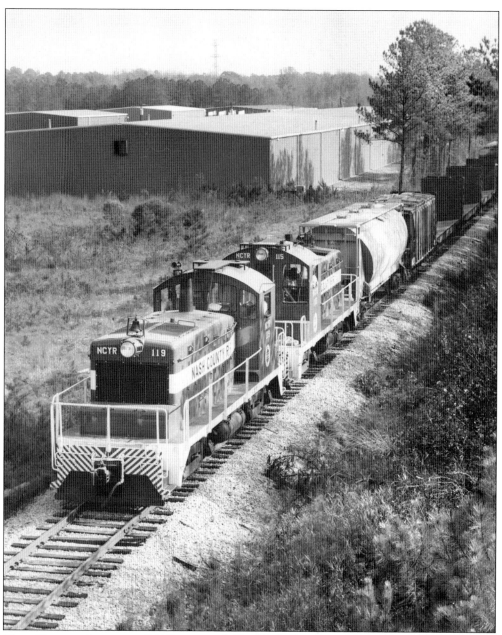

NASH COUNTY RAILROAD (1985–PRESENT). The Nash County was created by the L&S Holding Company in November 1985 to operate the 19-mile former CSX line from Rocky Mount to Spring Hope. The Nash County was included in the 1994 sale of the L&S Holding company to Gulf and Ohio Railways. (Mac Connery.)

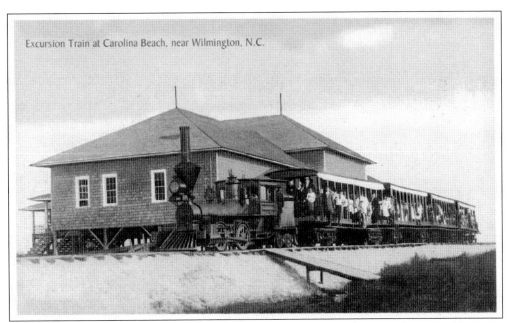

Excursion Train at Carolina Beach, near Wilmington, N.C.

NEW HANOVER TRANSIT COMPANY RAILROAD (1895–1919). The New Hanover's 45-minute ride to Carolina Beach ended on August 3, 1919, when the pier at the Doctor's Point burned. The company and its considerable real estate holdings were sold to new owners, who established the "Carolina Beach Railroad." Records indicate the Carolina Beach gave up efforts to resuscitate rail service to the beach by 1922. (New Hanover County Library.)

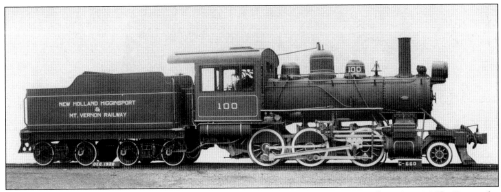

NEW HOLLAND, HIGGINSPORT, AND MOUNT VERNON RAILROAD (1923–1925). Part of a massive project to drain Lake Mattamuskeet and turn it into fertile farmland, 9 of the company's 35 miles of track lay in the pumped-out lake bed. Running from Wennona to the new town of New Holland, the line was a common carrier from 1923 until 1925. When the project developer went bankrupt, its successor turned the railroad into a private carrier for coal and supplies. The route died with the abandonment of the project in 1932 and the refilling of the lake. (PHMC.)

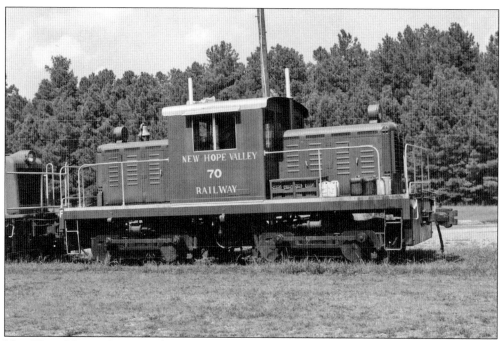

NEW HOPE VALLEY RAILWAY (1984–PRESENT). A 4-mile museum operation owned by the East Carolina chapter of the National Railway Historical Society, this line is part of the old Durham and Southern/Southern route from Bonsal to New Hope. (Bob Graham, Marsh collection.)

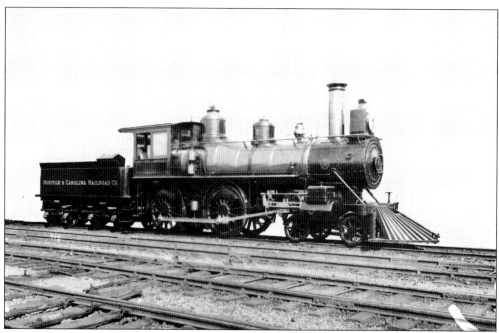

NORFOLK AND CAROLINA RAILROAD (1889–1900). The former Chowan and Southern Railroad, the Norfolk and Carolina eventually extended 120 miles from Norfolk, Virginia, to Rocky Mount. The Norfolk and Carolina became part of Atlantic Coast Line on April 18, 1900. (PHMC, H. L. Broadbelt collection.)

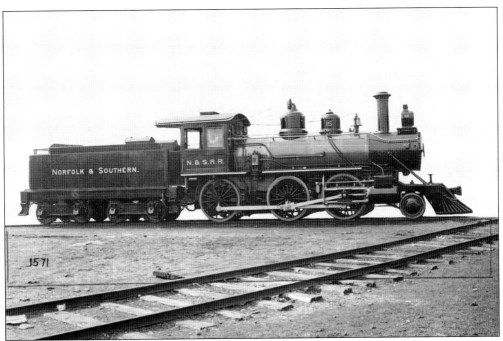

NORFOLK AND SOUTHERN RAILROAD (1891–1906). This reorganization of the Norfolk Southern Railroad added an ampersand to its name and included the Albemarle and Pantego Railroad. This railroad company was succeeded by the Norfolk and Southern Railway Company on November 23, 1906. (ALCO Historic Photos.)

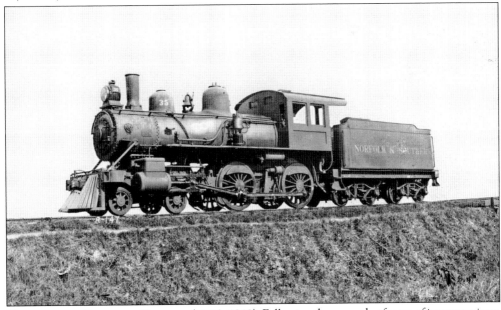

NORFOLK AND SOUTHERN RAILWAY (1906–1910). Following the example of some of its competitors, the Norfolk and Southern Railway consolidated the Norfolk and Southern Railroad with the Atlantic and North Carolina Railroad, the Beaufort and Western, the Pamlico, the Oriental and Western, and the Virginia and Carolina Coast. The railway name endured for only four years before the company became the Norfolk Southern Railroad. (ALCO Historic Photos.)

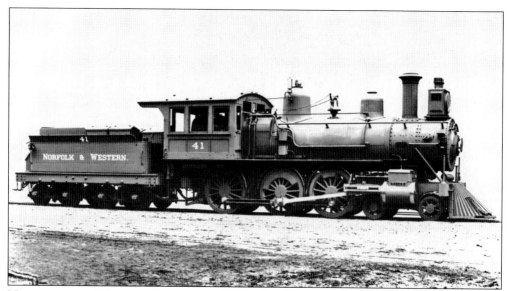

NORFOLK AND WESTERN RAILROAD (1881–1896). The Atlantic, Mississippi, and Ohio Railroad became the Norfolk and Western Railroad after the former's financial collapse and auction in 1881. The Norfolk and Western entered North Carolina through its 1892 lease of the Roanoke and Southern, providing service to the town of Winston. Pushed into bankruptcy by the Panic of 1893, the company was reorganized as Norfolk and Western Railway in 1896. (ALCO Historic Photos.)

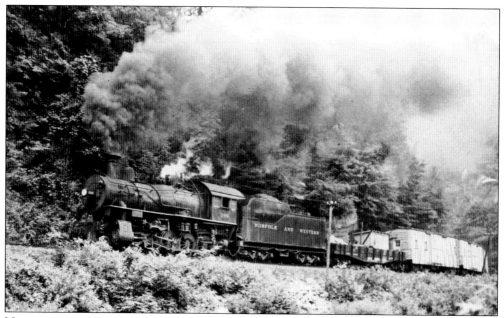

NORFOLK AND WESTERN RAILWAY (1896–1982). The reorganized successor to the Norfolk and Western (N&W) Railroad, the N&W Railway only operated 87.88 miles of mainline track and 71.3 additional miles of sidings and secondary track in North Carolina. The N&W did so by purchasing the Roanoke and Southern, the Lynchburg and Durham, and the Virginia-Carolina. The Norfolk and Western merged with the Southern Railway in 1982 to form the Norfolk Southern Corporation. (Doug Walker.)

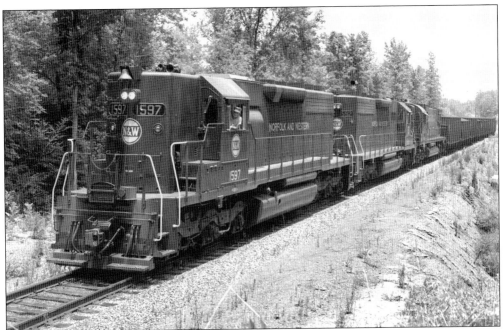

NORFOLK AND WESTERN RAILWAY. The Norfolk and Western operated mainline steam locomotives until 1958. While North Carolina saw some of the company's first diesels, steam was long gone from the road when this SD-35 powered coal train pulled into Hyco. (Norfolk Southern Corporation.)

NORFOLK, FRANKLIN, AND DANVILLE RAILWAY (1962–1983). A reorganization of the Atlantic and Danville by new owner Norfolk and Western, the Norfolk, Franklin, and Danville ran for 20 years before the track between Danville and Blanche was abandoned in June 1982. The rest of the company itself was gone within a year. (H. Reid, Marsh collection.)

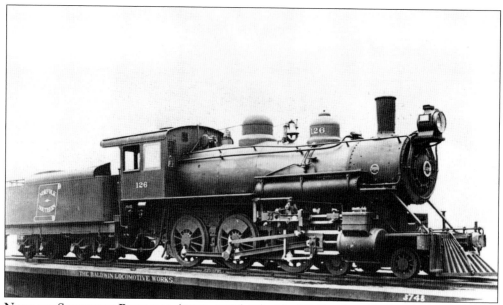

NORFOLK SOUTHERN RAILROAD (1910–1942). The Norfolk Southern Railroad enjoyed a stable name, if not always prosperity, for 29 years. Acquisitions over the years included seven smaller railroads in North Carolina alone. By 1932, a receiver was once again running the company. In the following decade, a number of branches were closed or sold; on January 21, 1942, the company changed its name a final time to become the Norfolk Southern Railway. (PHMC, H. L. Broadbelt collection.)

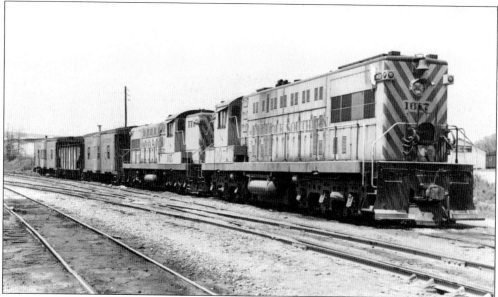

NORFOLK SOUTHERN RAILWAY (1942–1974). With a total of 733 system miles at its founding, the Norfolk Southern Railway shed more non-profitable lines over its remaining life. In 1961, the then-593-mile company moved its headquarters to Raleigh, and positive developments included a line to tap the phosphate mining near Aurora and the rebuilding of both the New Bern branch and the road's famed Albemarle trestle. The good news was sufficient for the Southern Railway to buy the company in 1974. (Wiley M. Bryan, Marsh collection.)

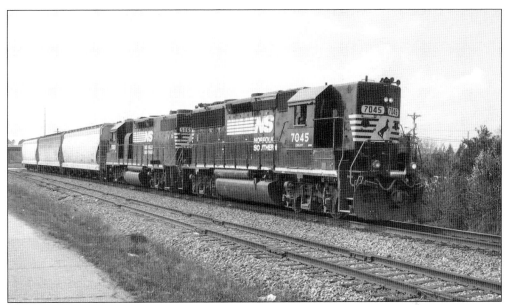

NORFOLK SOUTHERN RAILWAY (1982–PRESENT). The 1982 product of a merger of the Southern Railway and Norfolk and Western Railway, the Norfolk Southern conducts it operations through a number of subsidiaries. Norfolk Southern's 1,300 miles of track in North Carolina represents about 42 percent of the state's total. (Alan Coleman.)

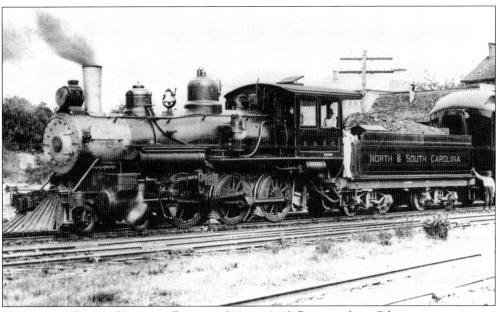

NORTH AND SOUTH CAROLINA RAILWAY (1910–1914). Running from Gibson to a connection with the Georgetown and Western Railway at the Pee Dee River, less than a mile of the company's 68-mile route lay within North Carolina. By the time the North and South Carolina and the Georgetown and Western railroads merged in 1914 to become the Carolina, Atlantic, and Western Railway, the North and South Carolina Railway was also operating Seaboard Air Line's 10-mile line from Gibson to Hamlet. (Mac Connery collection.)

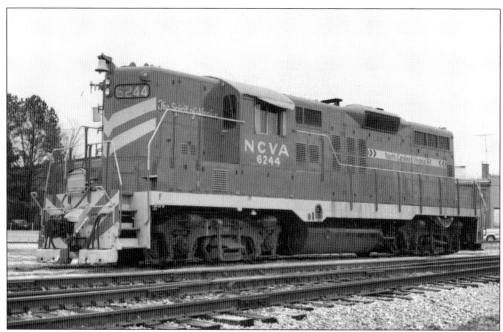

NORTH CAROLINA AND VIRGINIA RAILROAD (1987–PRESENT). RailAmerica established this company in 1987 to operate of 52 miles of former Atlantic Coast Line /CSX lines. With an office in Ahoskie, the North Carolina and Virginia runs from Boykins, Virginia, to Tunis via Kelford. (Mac Connery.)

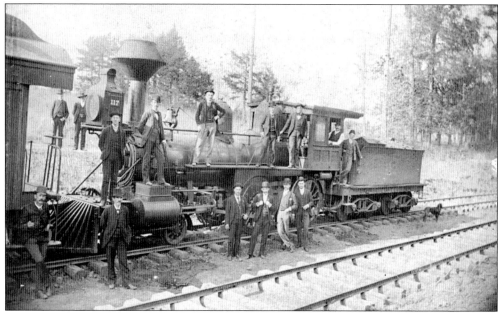

NORTH CAROLINA MIDLAND RAILROAD (1880–1915). An 1880 consolidation of several never-operational railroad companies (Dan Valley and Yadkin River Narrow-Gauge Railroad, Winston-Salem and Madison Railroad, and Winston-Salem and Mooresville Railroad), the North Carolina Midland line ran 26.11 miles from Winston-Salem to Mooresville. The company was leased to the Southern in 1915. (North Carolina State Archives.)

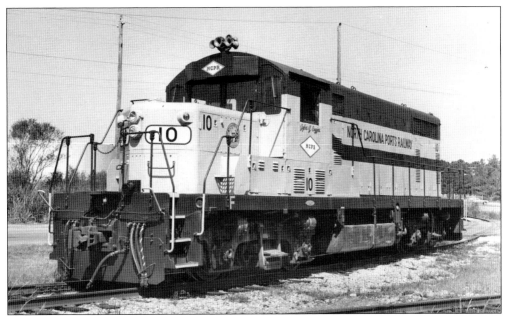

NORTH CAROLINA PORTS RAILWAY (1981–1986). The North Carolina Ports Railway Commission opened this common carrier railroad company on January 12, 1981, to operate rail operations in Wilmington and Morehead City. In 1986, the state leased the Morehead City operations to Carolina Rail Service as well as those in Wilmington to the Wilmington Terminal Railroad. (Mac Connery.)

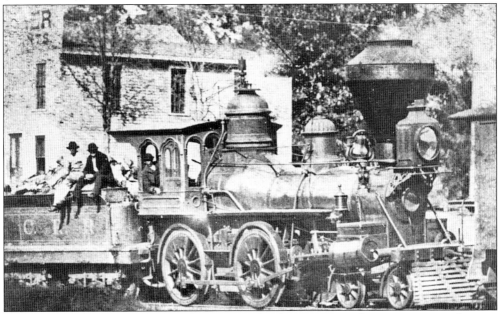

NORTH CAROLINA RAILROAD (1856–PRESENT). This state-owned company currently owns a 317-mile line that from runs from Morehead City to Charlotte. The original 223-mile North Carolina Railroad was leased to the Richmond and Danville in 1871, to the Southern in 1894, and to Norfolk Southern Corporation in 1982. The Atlantic and North Carolina was merged into the North Carolina Railroad in 1989. (North Carolina State Archives.)

NORTH STATE RAILROAD (1904–1923). This logging road served the now-vanished community of Cardenas, which was northwest of present-day Fuquay-Varina. The line was abandoned in April 1923. (Tim Carroll collection.)

NORTH-WESTERN NORTH CAROLINA RAILROAD (1873–1894). The Richmond and Danville built and leased this 25.19-mile line from Greensboro to Winston; by 1890, the company had extended it rails to what was then known as Wilkesborough. The North-Western was purchased by the Southern Railway in August 1894. (North Carolina State Archives.)

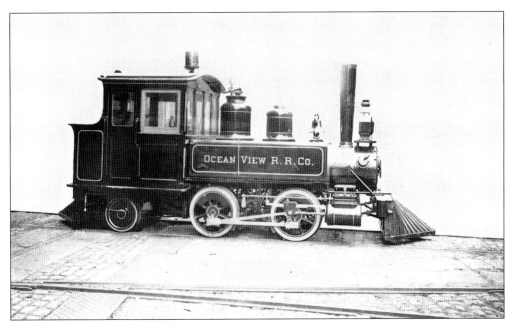

OCEAN VIEW RAILROAD (1887–1891). Built to nurture the beach tourist trade, the 1.51-mile Ocean View Railroad ran from its connection with the Wilmington Sea Coast Railroad at Atlantic Station to Hammocks, an island just inland of present-day Wrightsville Beach. The Ocean View Railroad was sold to the Wilmington Sea Coast Railroad on February 28, 1891. (PHMC, H. L. Broadbelt collection.)

OHIO RIVER AND CHARLESTON RAILWAY (1894–1898). Successor to the Charleston, Cincinnati, and Chicago Railroad, the Ohio River and Charleston (OR&C) followed the same dismal financial path as its predecessor. In 1898, the company's 174-mile Charleston-to-Marion line was sold to the newly formed South Carolina and Georgia Extension Railroad; the Johnson City–to–North Carolina segment remained the property of the dormant OR&C until the line was purchased by George L. Carter's new South and Western Railway in 1902. (Ohio location postcard, PHMC.)

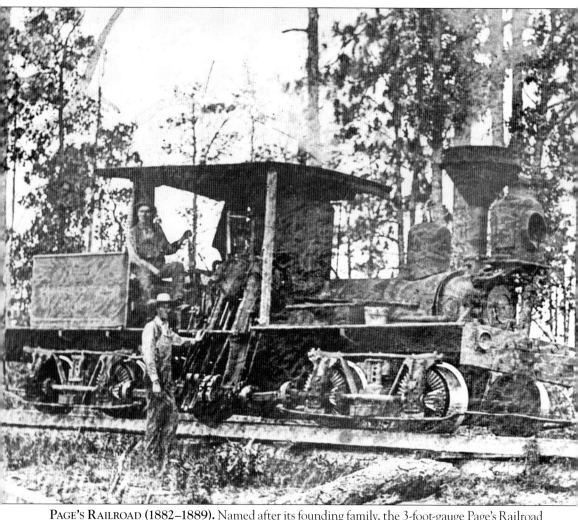

PAGE'S RAILROAD (1882–1889). Named after its founding family, the 3-foot-gauge Page's Railroad became the Aberdeen and West End Railroad in February 1889. (Doug Walker collection.)

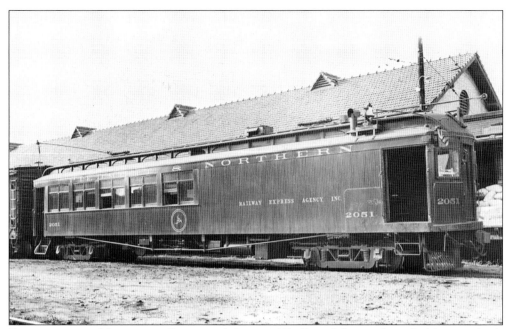

PIEDMONT AND NORTHERN RAILWAY (1911–1969). Famed for its electrified lines in both Carolinas, the North Carolina line ran from Charlotte to Gastonia with a branch from Mount Holly to Belmont. The Piedmont and Northern (P&N) was operated under joint management with James B. Duke's other North Carolina railroad, the Durham and Southern, from 1931 until 1954, the same year that saw the replacement of overhead wires and electric motors by diesel locomotives. The P&N was sold to the Seaboard Coast Line in 1969. (Interurban car, George Votava, Kalmbach Memorial Library; electric motor, C. K. Marsh.)

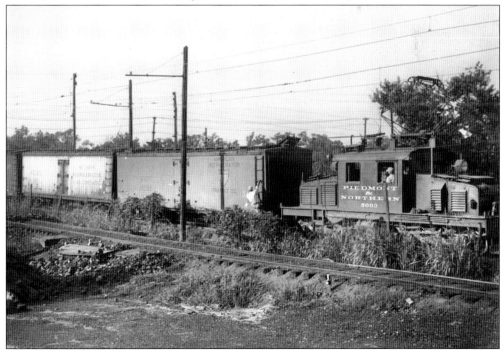

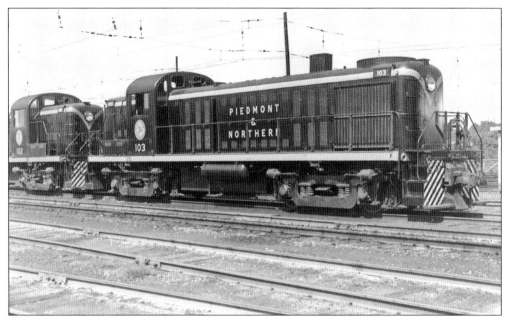

PIEDMONT AND NORTHERN. This ALCO RS-3 was built in 1951 and helped end electric operations on the Piedmont and Northern. (C. K. Marsh Jr.)

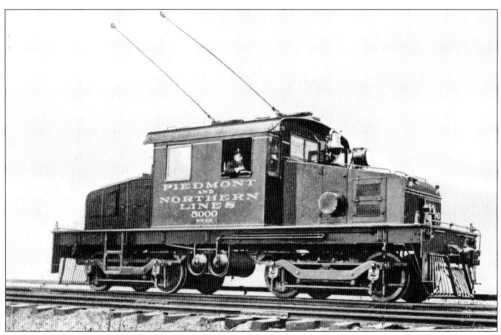

PIEDMONT TRACTION COMPANY (1910–1914). The North Carolina predecessor of what was to become the Piedmont and Northern Railway, Piedmont Traction, and South Carolina's counterpart, the Greenville, Spartanburg, and Anderson Railway, were merged into the P&N in 1914. (Westinghouse Company circular, Rhett George collection.)

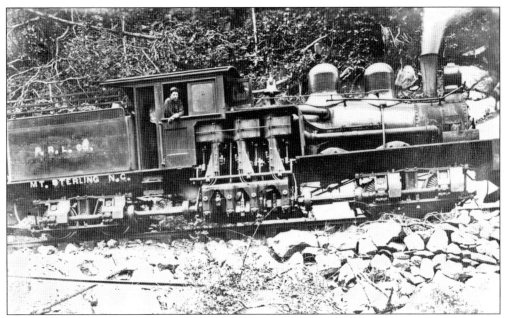

PIGEON RIVER RAILWAY (1906–1910, 1911–1931). The Pigeon River Railway was an 11.87-mile line from West Canton to Sunburst. Operated under lease on an as-needed basis by the Tennessee and North Carolina Railway, the Pigeon River Railway was abandoned on October 30, 1931. (Walter Casler, Mallory H. Farrell collection.)

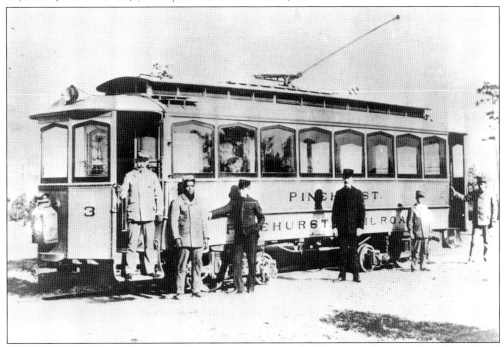

PINEHURST ELECTRIC RAILROAD COMPANY (1896–1910). This trolley line ran from the railroad depot in Southern Pines to the golf club at Pinehurst. A dispute between the two communities led to an irate Southern Pines removing its portion of the line in 1905; local Pinehurst trolley service lasted five more years. (Tufts Archive, Givens Memorial Library.)

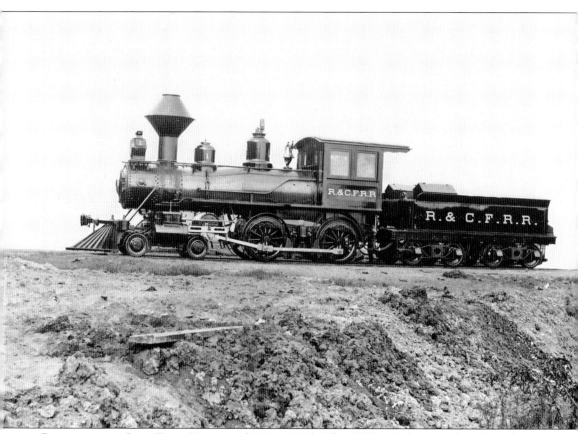

RALEIGH AND CAPE FEAR RAILWAY (1899–1905). This 20.8-mile line ran from Sippahaw to Caraleigh and from the latter town to Raleigh. In 1905, it was absorbed by the Raleigh and Southport Railway. (ALCO Historic Photos.)

RALEIGH AND CHARLESTON RAILROAD (1905–1933). The successor to the Carolina Northern Railroad, the Raleigh and Charleston was set up by the Seaboard Air Line to own and operate a 41-mile line between Lumberton and Marion, South Carolina. In 1933, the 23 miles from Lumberton to Lakeview, South Carolina, were abandoned, and the remainder of the line met the same fate in 1941. (S. David Carriker collection.)

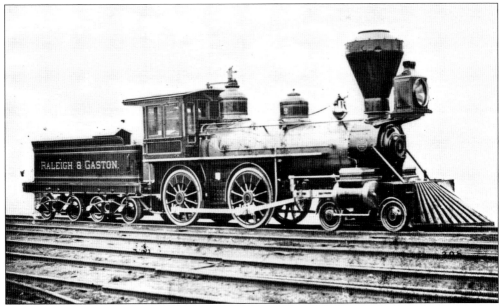

RALEIGH AND GASTON RAILROAD (1840–1900). The state's second railroad, the 86-mile line from Raleigh to Gaston opened in April 1840. Financial misfortunes resulted in a number of owners over the years, a list that includes the state of North Carolina. The Raleigh and Gaston became part of Seaboard Air Line in 1900. (PHMC, H. L. Broadbelt collection.)

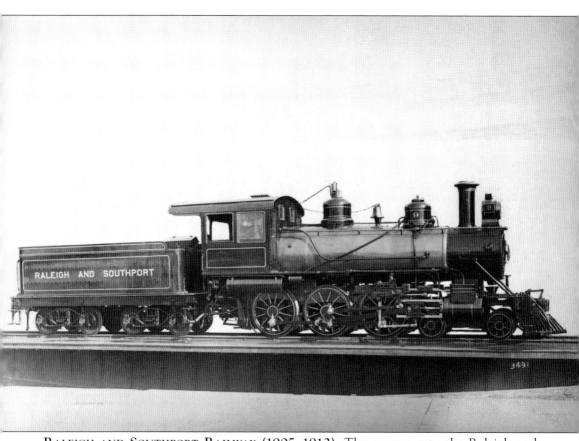

RALEIGH AND SOUTHPORT RAILWAY (1905–1912). The successor to the Raleigh and Cape Fear Railway, the Raleigh and Southport was reorganized by owner Norfolk Southern Railroad into the Raleigh, Charlotte, and Southern Railway in February 1912. (PHMC, H. L. Broadbelt collection.)

RANDOLPH AND CUMBERLAND RAILWAY (1907–1924). Successor to the Randolph and Cumberland Railroad, this line was sold at public auction on August 4, 1924, to the town of Carthage, which turned its operations over to the newly formed Moore Central Railway. (Railway House.)

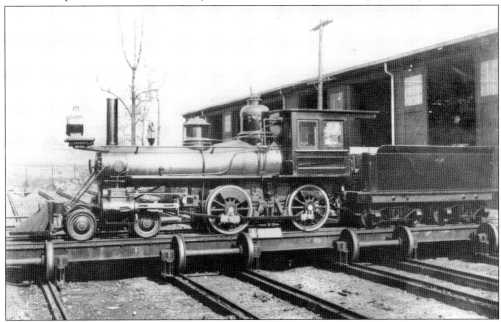

RED SPRINGS AND BOWMORE RAILROAD (1896–1918). This 16-mile, 3-foot-gauge logging road was the successor to Red Springs Railway and Lumber Company line, which ran between the namesake towns with a branch to Wagram. Reduced in length as areas were logged out, the Red Springs and Bowmore's remaining track was abandoned in October 1918. (Gerald Best, S. David Carriker collection.)

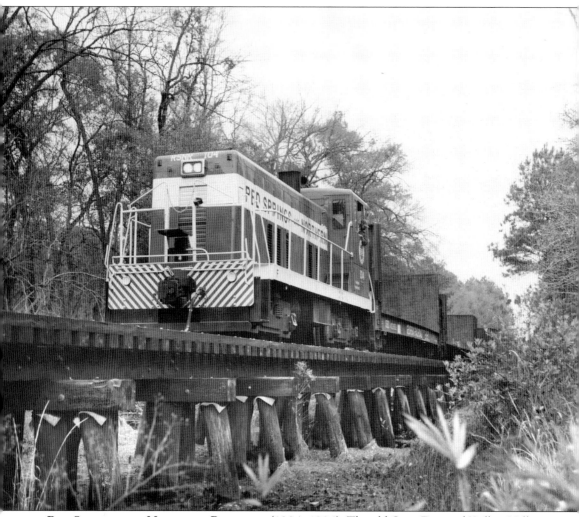

RED SPRINGS AND NORTHERN RAILROAD (1984–1994). The old Cape Fear and Yadkin Valley line from Parkton to Red Springs was sold by Seaboard System in 1984 to Advancement, Inc., which leased it to the L&S Holding Company for operation as Red Springs and Northern. After a decade of operation, the unprofitable line was sold to Red Springs and Northern Foundation. The line is intact and is frequently used by motor car, or "speeder," excursions. (Mac Connery.)

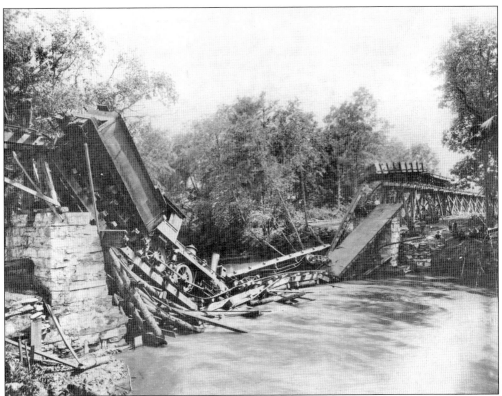

RICHMOND AND DANVILLE RAILROAD (1856–1894). Chartered in 1847, the Richmond and Danville became the largest railroad company in North Carolina, with ownership or control of more than 500 miles of track at its peak. Hard times caught up with the Richmond and Danville in August 1894; most of the company's rail lines became part of the Southern Railway. (SRHA/SM.)

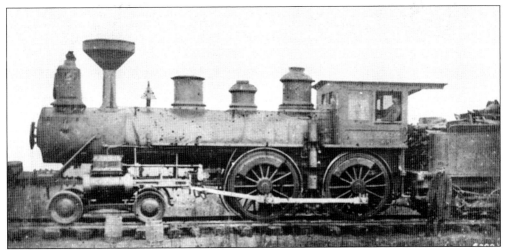

ROANOKE AND SOUTHERN RAILWAY OF NORTH CAROLINA (1887–1896). This Roanoke, Virginia, to Winston line had 47 of its 121 miles within North Carolina. The Roanoke and Southern was leased to Norfolk and Western in 1892 and bought by same in 1896. (Norfolk Southern Corporation.)

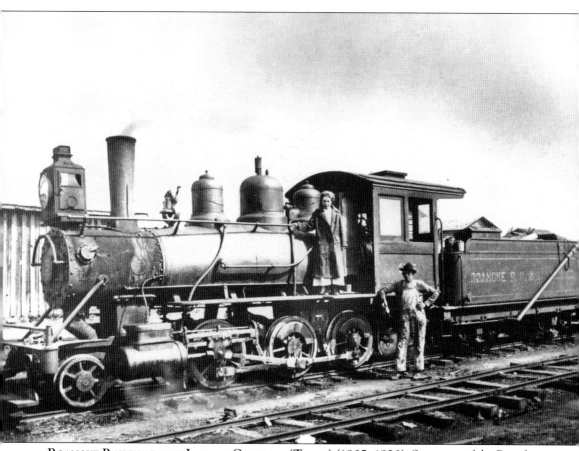

ROANOKE RAILROAD AND LUMBER COMPANY (THIRD) (1905–1920). Successor of the Beaufort and Pamlico Railroad, this third venture to use the Roanoke Railroad and Lumber Company name looked for logs elsewhere and ran from Bath to Pamlico Beach. After a 1920 fire, the line was abandoned. (John Bass collection.)

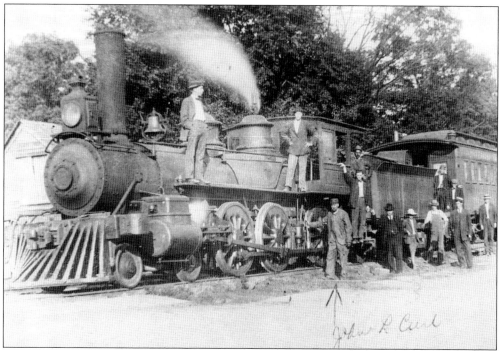

ROANOKE RIVER RAILWAY (1907–1919). This 11-mile road between Manson and Townsville was built on roadbed remnants of the Roanoke Valley Railroad. The company failed after a bridge washout in 1918, and its line was sold at auction to become the Townsville Railroad. (Bob Drake collection.)

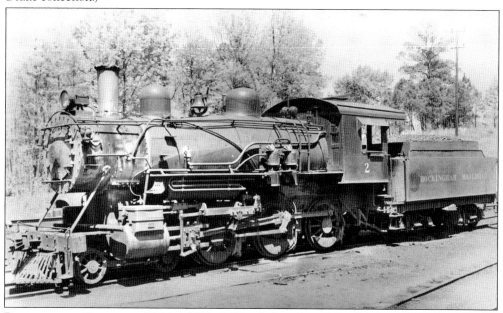

ROCKINGHAM RAILROAD (1912–1968). A 19-mile line from Roberdel through Rockingham to Gibson, the Rockingham became an independent part of Atlantic Coast Line in 1922. The line was made redundant by the Atlantic Coast Line/Seaboard Air Line merger and was abandoned in 1968. (Bob Drake collection.)

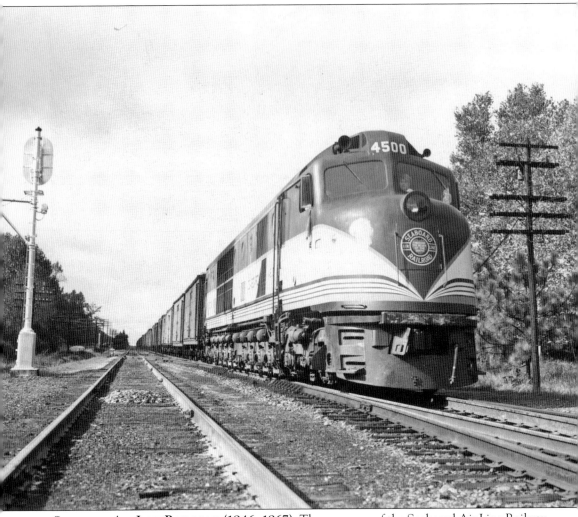

SEABOARD AIR LINE RAILROAD (1946–1967). The successor of the Seaboard Air Line Railway Company, this company merged with the Atlantic Coast Line Railroad in 1967 to become the Seaboard Coast Line. (John Hemmer, Tufts Archive.)

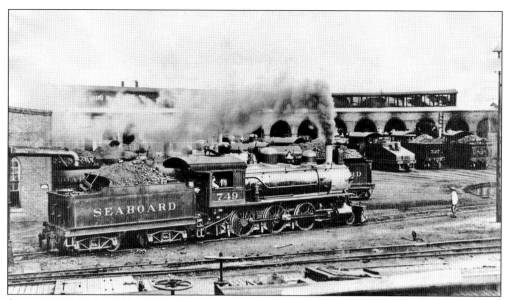

SEABOARD AIR LINE RAILWAY (1900–1915). Adopting the Seaboard Air-Line name used by its predecessor roads as a collective marketing banner, the Seaboard Air Line Railway (SALRy) began operations in April 1900 with more than 550 miles of track in North Carolina. On November 16, 1915, the SALRy was reorganized as the Seaboard Air Line Railway Company. (Doug Walker collection.)

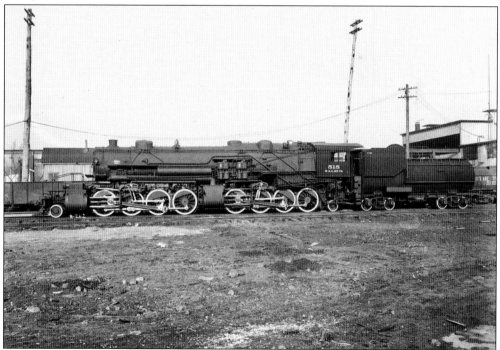

SEABOARD AIR LINE RAILWAY COMPANY (1915–1946). The Seaboard Airline Line Railway Company operated 629.21 miles of track in North Carolina by 1945. Financial woes led to the company to a foreclosure sale on May 31, 1945. On January 1, 1946, the company was reorganized as the Seaboard Air Line Railroad. (ALCO Historic Photos.)

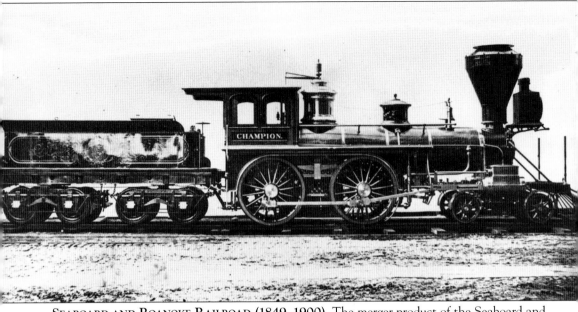

SEABOARD AND ROANOKE RAILROAD (1849–1900). The merger product of the Seaboard and Roanoke Railroad of Virginia and North Carolina's Roanoke Railroad Company, the Seaboard and Roanoke rebuilt its line in 1851 and organized/leased the Roanoke and Tar River. The 119-mile railroad became part of the Seaboard Air-Line system in 1890. (Doug Walker collection.)

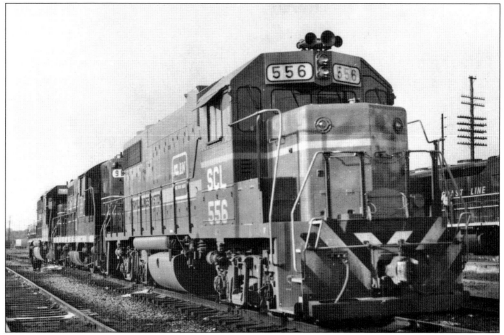

SEABOARD COAST LINE (1967-1983). Formed by the July 1, 1967, merger of the Atlantic Coast Line and Seaboard Air Line, the Seaboard Coast Line (SCL) enlarged its operations in North Carolina by acquiring the Piedmont and Northern in 1969 and the Durham and Southern in 1976. The SCL merged with Chessie System and Western and Maryland's holding company in 1983 to become the Seaboard System Railroad. (Wiley M. Bryan, Mac Connery collection.)

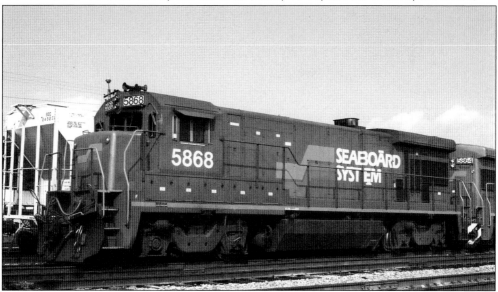

SEABOARD SYSTEM RAILROAD (1983–1986). By 1983, the Seaboard System Railroad was second in size only to Norfolk Southern in North Carolina, and it was by then operating the former Louisville and Nashville and Clinchfield railroads in addition to those of its Atlantic Coast Line/Seaboard Air Line predecessors. On July 1, 1986, the Seaboard System and its "Family Lines" became part of CSX Transportation. (Bill Folsom, Lon Coone collection.)

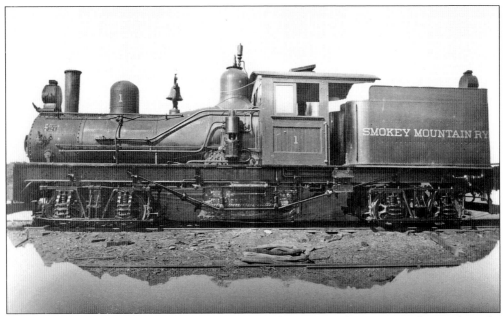

SMOKY MOUNTAIN RAILWAY (1909–1927). A 9.6-mile Ritter Lumber Company logging line, the Smoky Mountain Railway ran from its connection with the Carolina and Tennessee Southern Railway at Ritter to the community of Bone Valley. (SRHA/SM.)

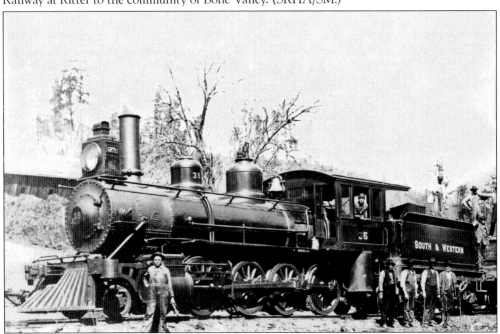

SOUTH AND WESTERN RAILWAY (1902–1908). In July 1902, George L. Carter and his business partners bought the old Ohio River and Charleston Railway line, which ran from Johnson City, Tennessee, to Huntdale, and reorganized it as the South and Western Railway (S&W). With loads of cash and first-rate engineering, the South and Western expanded to Spartanburg, South Carolina, and north to Dante, Virginia. The S&W was reorganized as the Carolina, Clinchfield, and Ohio in 1908. (L. B. Coyle, Mac Connery collection.)

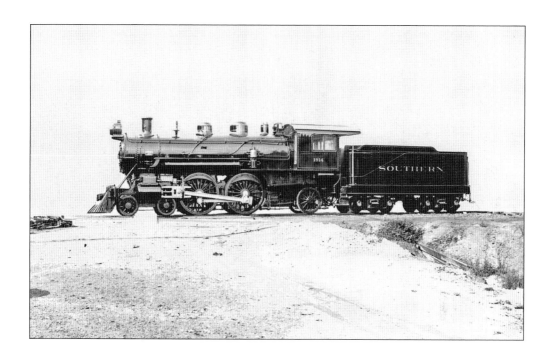

SOUTHERN RAILWAY COMPANY (1894–1982). Created from the ruins of the Richmond and Danville, the Southern combined the finances of John Pierpoint Morgan and the operating genius of Samuel Spencer on June 18, 1894. In North Carolina, the Southern Railway and its subsidiaries owned the old Richmond and Danville/Piedmont Railroad mainlines and leased the North Carolina Railroad. (No. 1914, ALCO Historic Photos; train No. 36 at Charlotte, Walter Thrall, Marvin Black collection.)

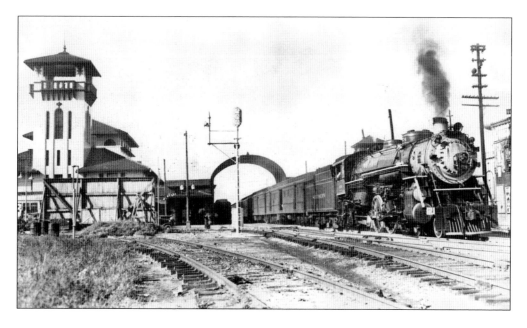

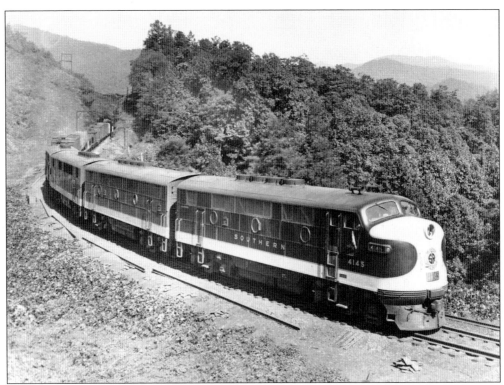

SOUTHERN RAILWAY. The Southern Railway was an early pioneer in diesel locomotives, and it officially made its last steam-powered run on June 17, 1953. The Southern merged with the Norfolk and Western Railway in 1982 to become the Norfolk Southern Corporation. (Above, Frank Clodfelter, Jerry Ledford collection; below, Mac Connery.)

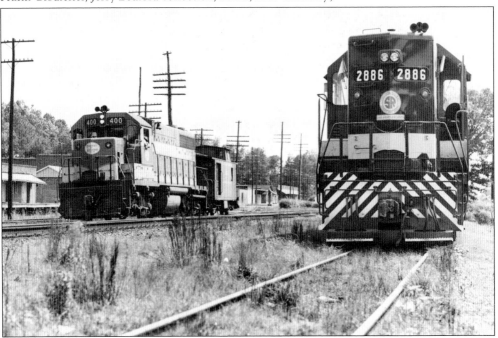

GEE AINT THIS A LONESOME PLACE, UNIVERSITY, N. C.

STATE UNIVERSITY RAILROAD (1882–PRESENT). This 10.2-mile line from Glenn to Carrboro was controlled by the Richmond and Danville by 1883 and by the Southern Railway System from 1894 until 1982. The company is a currently a Norfolk Southern Corporation subsidiary. (North Carolina State Archives.)

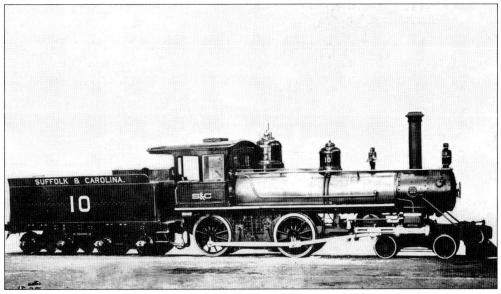

SUFFOLK AND CAROLINA RAILWAY (1885–1906). Successor to the Nansemond Land, Lumber, and Narrow-Gauge Railroad Company, the Suffolk and Carolina ran from Suffolk, Virginia to Sunbury. Built to a 3.5-foot gauge, the line was extended to Edenton by 1902 and standard-gauged in 1903. The company became the Virginia and Carolina Coast Railroad in January 1906. (Frank Moore collection.)

TALLULAH FALLS RAILWAY (1897–1961). The Tallulah Falls ran from Cornelia, Georgia, to Franklin by 1907 and required 42 trestles in its 58-mile route. The final run on the Tallulah Falls was on March 25, 1961, and the line was scrapped by 1962. (Above, Mac Connery collection; below, Keith Ardinger collection.)

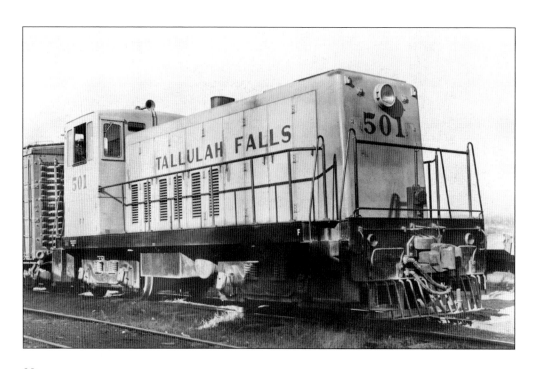

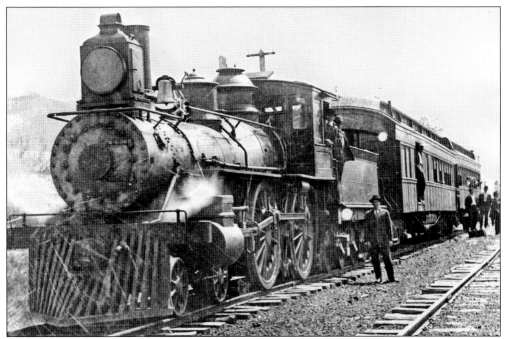

TENNESSEE AND NORTH CAROLINA RAILROAD (1906–1920). A 21-mile logging line from Crestmont to Newport, Tennessee, the Tennessee and North Carolina (T&NC) was sold under a court order on June 7, 1920. Three weeks later, the line became the Tennessee and North Carolina Railway. (Jerry Ledford collection.)

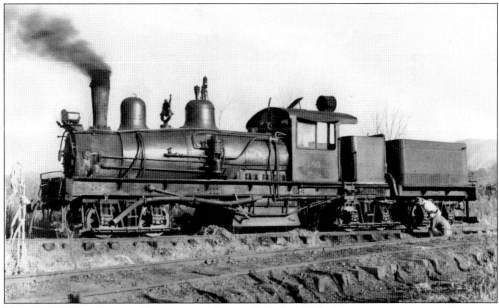

TENNESSEE AND NORTH CAROLINA RAILWAY (1920–1933). The successor to the Tennessee and North Carolina Railroad, this company's North Carolina operations included a 21-mile line from Crestmont to Newport, Tennessee, the former Carolina and Georgia Railway line from Andrews to Hayesville, and the leased Pigeon River Railway line from West Canton to Sunburst. (Tom King collection.)

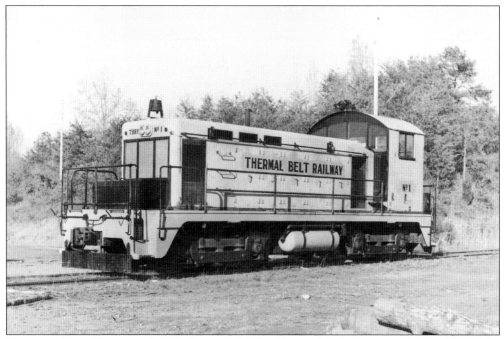

THERMAL BELT RAILWAY (1990–PRESENT). The Thermal Belt connects Bostic, Alexander Mills, and Forest City to Spindale by operating 8.5 miles of ex-Southern and CSX tracks owned by the Rutherford Railroad Development Corporation. (Tom Sink, Marsh collection.)

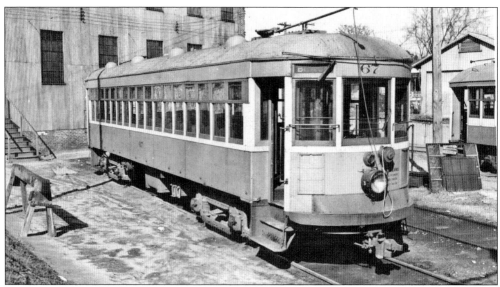

TIDEWATER POWER COMPANY (1907–1940). The successor to Consolidated Railways, Light, and Power Company, the Tidewater maintained interurban service from downtown Wilmington to Wrightsville Beach until April 27, 1940. (Robert Hanft, Mac Connery collection.)

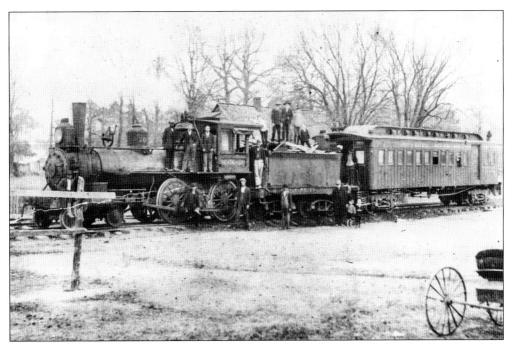

TOWNSVILLE RAILROAD (1919–1933). The community of Townsville bought 11 miles of the washed-out Roanoke River Railway between Manson and Townsville for $70,000 in August 1919 and operated it until abandonment in 1933. (George Holden Jr./Jim Harris collection.)

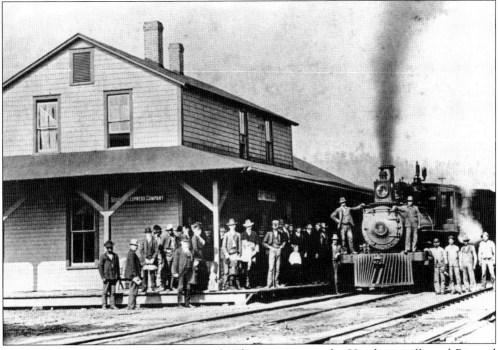

TRANSYLVANIA RAILROAD (1899–1906). The successor to the Hendersonville and Brevard Railroad, the Transylvania extended its line 10 miles to Lake Toxaway. The company was sold to Southern Railway in 1906. (Claude Clazener, Mac Connery collection.)

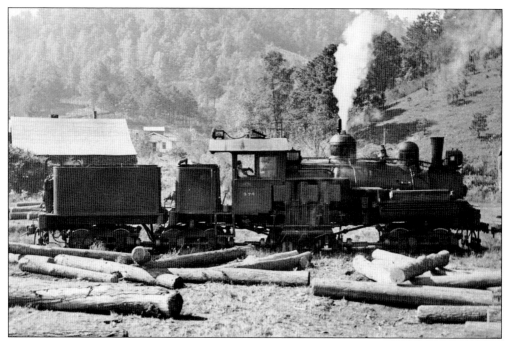

TUCKASEEGEE AND SOUTHEASTERN RAILROAD (1922–1945). Owner Blackwood Lumber Company turned its logging road into a passenger-carrying common carrier in 1922 to serve Western North Carolina Normal College (present-day Western Carolina University) at Cullowhee. Running from Sylva to East LaPorte, the 12.18-mile line closed when Blackwood's lumber operations ended on March 19, 1945. (Norman Williams, Mac Connery collection.)

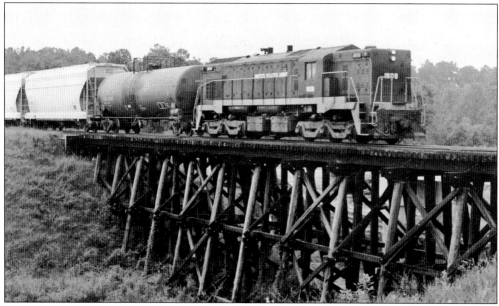

U.S. ARMY RAILROAD (1944–PRESENT). The U.S. Army Transportation Terminal's U.S. Army Railroad operates the Malmo–to–Sunny Point segment of the old Atlantic Coast Line/ Wilmington and Conway line, accessing the western side of Military Ocean Terminal Sunny Point. (Mac Connery.)

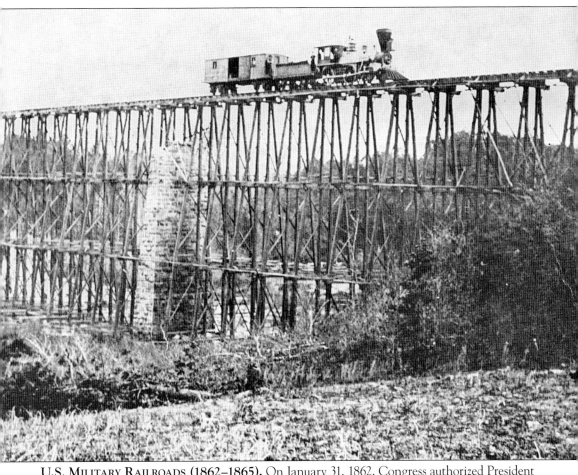

U.S. MILITARY RAILROADS (1862–1865). On January 31, 1862, Congress authorized President Lincoln "to take possession of any and all railroads" and operate them as part of the federal army. In April 1865, after the end of the war, the U.S. Military Railroads (USMRR) began restoring the Confederate roads to service and returning them to their owners. The 1865 return dates for its North Carolina railroads were as follows: the Atlantic and Western, October 25; the North Carolina, October 22; the Raleigh and Gaston, May 3; and the Wilmington and Weldon, August 27. (North Carolina State Archives.)

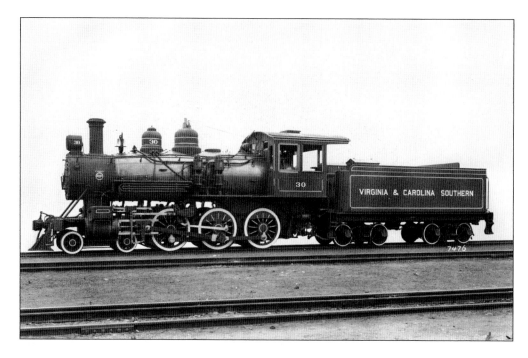

VIRGINIA AND CAROLINA SOUTHERN RAILROAD (1907–1968). An 83-mile line from Hope Mills to Capol, the Virginia and Carolina Southern also had a spur from St. Paul to Elizabethtown. The company was controlled by Atlantic Coast Line (ACL) but operated as an independent road from 1922 until the ACL/Seaboard Coast Line merger. (Above, PHMC, H. L. Broadbelt collection; below, William Moneypenny, John Porter collection.)

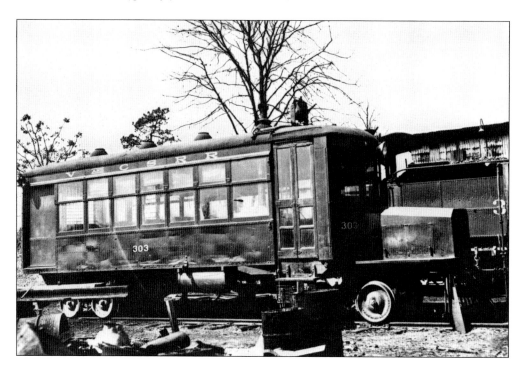

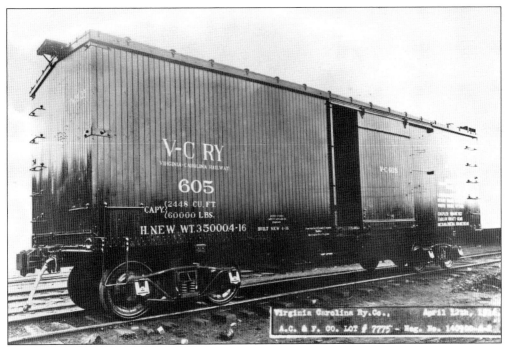

VIRGINIA-CAROLINA RAILROAD (1898–1918). Previously the Abingdon Coal and Iron Railroad, the "Virginia Creeper" ran from Abingdon, Virginia, to Elkland (present-day Todd) by 1905. The company became part of the Norfolk and Western Railway in 1918; by 1933, the former Virginia-Carolina line was cut back to West Jefferson. (Mac Connery collection.)

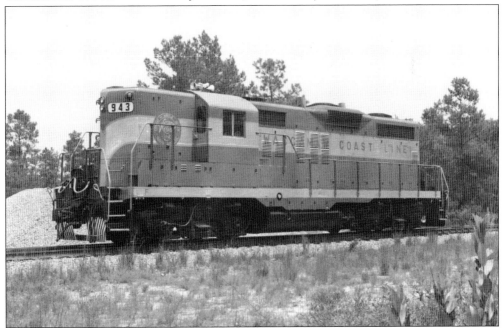

WACCAMAW COAST LINE RAILROAD, CLINTON DIVISION (1984–1995). Owned by the Carolina Southern, this 3.5-mile switching road connected with the CSX. In 1995, the operation became the Clinton Terminal Railroad. (Mac Connery.)

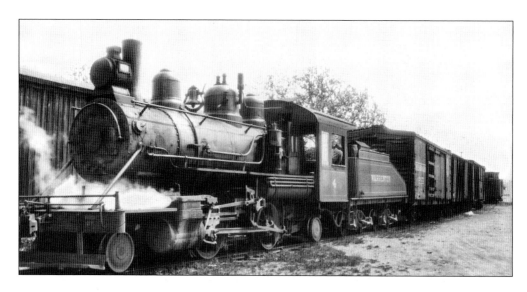

WARRENTON RAILROAD (1884–1985). Warrenton city fathers unwisely decided to bar the Raleigh and Gaston Railroad from running through their town. To correct the mistake, the same gentlemen built a 3-mile railroad from Warrenton to the Raleigh and Gaston at Warren Plains. The Warrenton operated for more than a century, shutting down with the end of Seaboard System service to Warren Plains in August 1985. (Above, Tom G. King collection; below, Tom G. King, Marsh collection.)

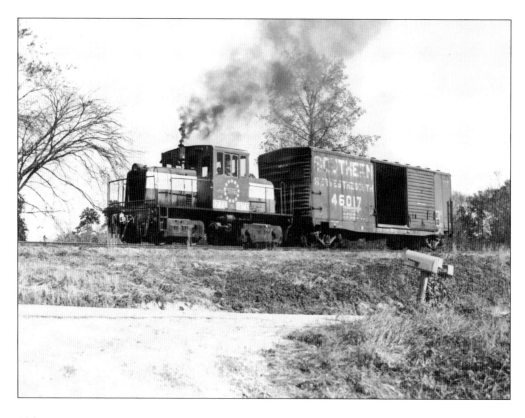

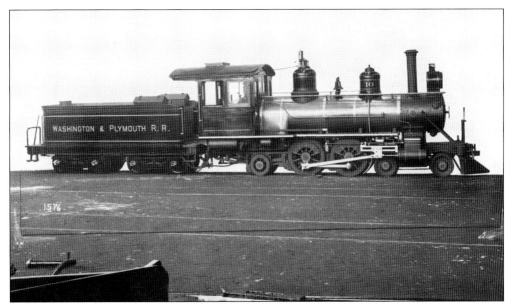

WASHINGTON AND PLYMOUTH RAILROAD (1901–1904). The common carrier reincarnation of a 3-foot-gauge logging road built by the original Roanoke Railroad and Lumber Company, the line was standard-gauged when it became part of Norfolk and Southern in 1904. (PHMC, H. L. Broadbelt collection.)

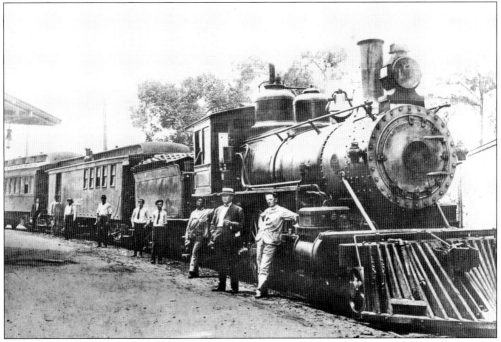

WASHINGTON AND VANDEMERE RAILROAD (1912–1944). After 10 years of independence, this 41.7-mile line was leased to the Atlantic Coast Line in 1922. The ACL purchased the Washington and Vandemere in 1944 and abandoned its track six years later. (Larry Goolsby collection.)

WATAUGA AND YADKIN RIVER (W&YR) RAILROAD (1912–1913). A subsidiary of the Grandin Lumber Company, the W&YR was the successor to the Yadkin River Railroad. The company's 20-mile line ran from North Wilkesboro to Grandin, with a spur to Darby. In receivership by 1913, the company was reorganized as the Watauga and Yadkin Valley Railroad by the same owners. (Jim Tomlinson collection.)

WATAUGA AND YADKIN VALLEY RAILROAD (1913–1918). The reorganized Watauga and Yadkin River Railroad, this line was washed out by the flood of 1916. Rebuilt only to be knocked out by floods again in October 1918, the line was sold for $160,000. In 1932, the inactive property was sold for $350 in back taxes, and new owner C. E. Jenkins tried unsuccessfully to reactivate the line as the Wilkes and Western Railroad. (Jim Tomlinson collection.)

WESTERN NORTH CAROLINA RAILROAD (1857–1894). This 185-mile line from Salisbury to Paint Rock was completed by 1879. The Richmond and Danville (R&D) leased the Western North Carolina Railroad (WNCRR) in 1886 and extended the road by completing the 115.3-mile, Asheville-to-Murphy branch under the R&D name in 1890. To the anguish of many local citizens, the Richmond and Danville replaced the Western North Carolina Railroad's name in local newspaper advertisements with its own by 1889. After the R&D's failure, the Western North Carolina Railroad was purchased by the Southern Railway on June 15, 1894. (Doug Walker and Matthew Bumgarner collection.)

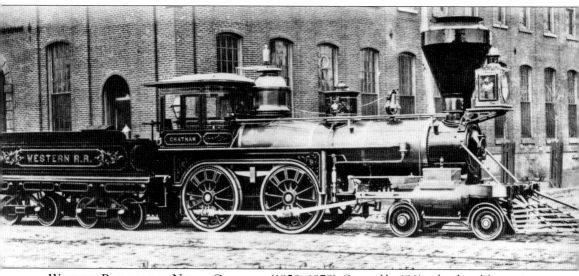

WESTERN RAILROAD OF NORTH CAROLINA (1858–1879). Opened by 1861 to haul coal from mines near Egypt to Fayetteville, this line was a critical part of the railroads serving the Confederacy. The Western Railroad was merged into the Cape Fear and Yadkin Valley Railroad on February 25, 1879. (Frank Moore collection.)

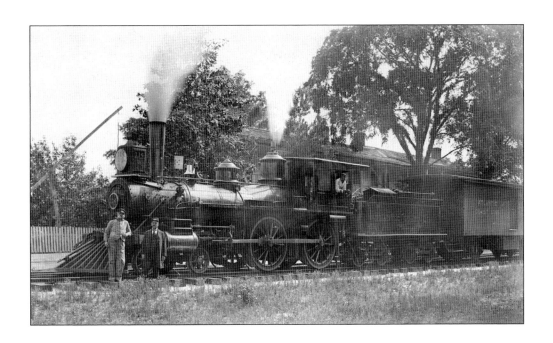

WILMINGTON AND WELDON RAILROAD (1855–1900). The former Wilmington and Raleigh Railroad, the Wilmington and Weldon was leased in 1872 to the Wilmington, Columbia, and Augusta (WC&A). The lease ended in 1878 with the bankruptcy of the WC&A. In 1886, the Wilmington and Weldon directed all of its affiliates to go to standard gauge, a process that was completed in three years. In 1900, the Wilmington and Weldon became a critical part of the Atlantic Coast Line. (Above, Wilmington Railroad Museum; No. 139, ALCO Historic Photos.)

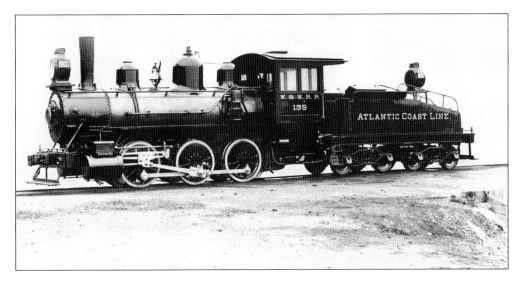

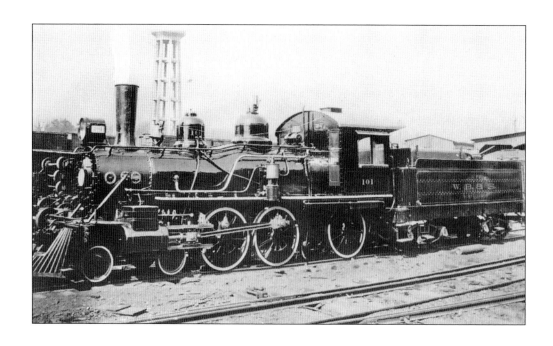

WILMINGTON, BRUNSWICK, AND SOUTHERN RAILROAD (1912–1941). Opened in June 1912, this 30-mile short line ran between Southport and an Atlantic Coast Line connection at Navassa, with the ACL providing the final 2-mile ride into Wilmington. The Wilmington, Brunswick, and Southern Railroad ceased operations in 1941 and was sold for scrap on July 19, 1943. (Above, SRHA/SM; below, R. M. Hanft, Mac Connery collection.)

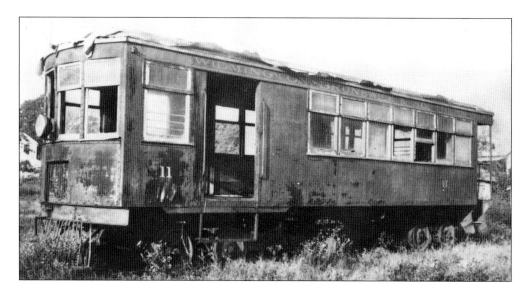

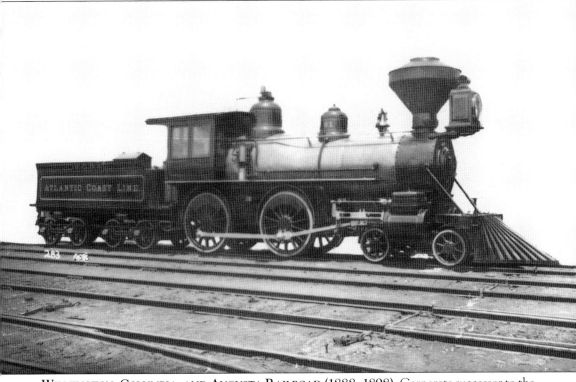

WILMINGTON, COLUMBIA, AND AUGUSTA RAILROAD (1888–1898). Corporate successor to the Wilmington, Columbia, and Augusta Railroad, this 192-railroad was leased to the Wilmington and Weldon on June 1, 1885. The WC&A became part of the Atlantic Coast Line of South Carolina on August 16, 1898. (PHMC, H. L. Broadbelt collection.)

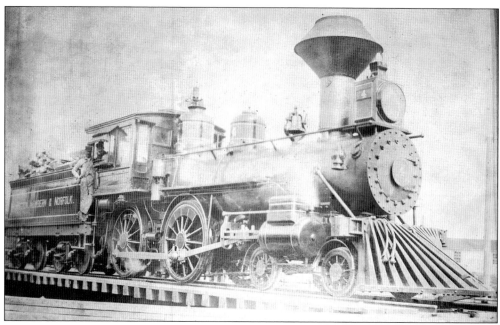

WILMINGTON, NEWBERN, AND NORFOLK RAILROAD (1894–1897). The successor of the Wilmington, Onslow, and East Carolina Railroad, this 87.25-mile line was taken over by the Wilmington and Weldon on July 15, 1897. (PHMC.)

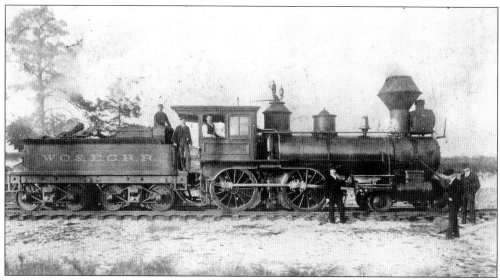

WILMINGTON, ONSLOW, AND EAST CAROLINA RAILROAD (1891–1894). This 50.15-mile road from Wilmington to Jacksonville opened on February 1, 1891. Owner East Carolina Land and Railway Company extended the track from Jacksonville to what was then spelled "Newbern" by July 1, 1893. The company was sold and renamed as the Wilmington, Newbern, and Norfolk Railroad on February 8, 1894. (PHMC.)

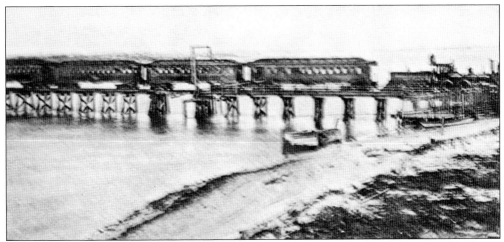

WILMINGTON SEA COAST RAILROAD (1888–1901). In June 1888, the Wilmington Sea Coast opened its 10.31-mile line from Wilmington to Atlantic Station, where passengers transferred to the Ocean View Railroad for the final portion of their journey to Hammocks. The Sea Coast bought the Ocean View on February 28, 1891, creating a 11.81-mile line from downtown Wilmington to Ocean View (incorporated as Wrightsville Beach in 1899). The Wilmington Sea Coast Railroad was sold to Consolidated Railways, Light, and Power Company on October 7, 1901. (North Carolina State Archives.)

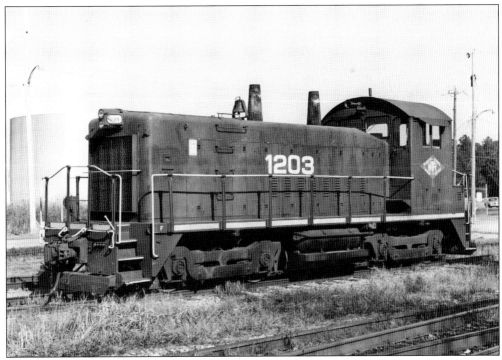

WILMINGTON TERMINAL RAILWAY (1986–PRESENT). The North Carolina Ports Railway Commission replaced its own rail operations in Wilmington with this lessor partnership in 1986. Genesee and Wyoming subsidiary Rail Link currently operates the 4-mile mainline and 14 miles of state-owned port tracks in Wilmington. (Warren Calloway, Marsh collection.)

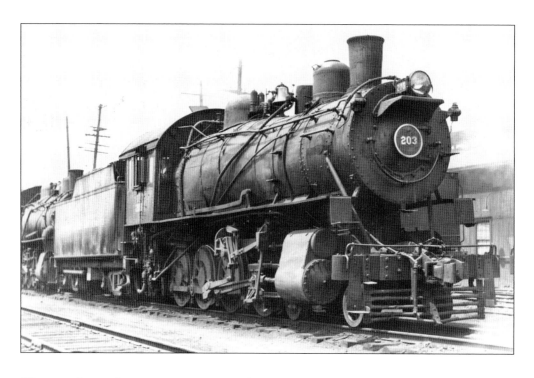

WINSTON-SALEM SOUTHBOUND RAILWAY (1910–PRESENT). Launched by the Fries family and other prominent businessmen in 1910, this 80-mile line runs from Winston-Salem to Wadesboro and was originally a partnership effort of the Norfolk and Western (N&W) and the Atlantic Coast Line. The company is currently owned by N&W/ACL successors Norfolk Southern and CSX. (Above, Marsh collection; below, Bill Taylor collection.)

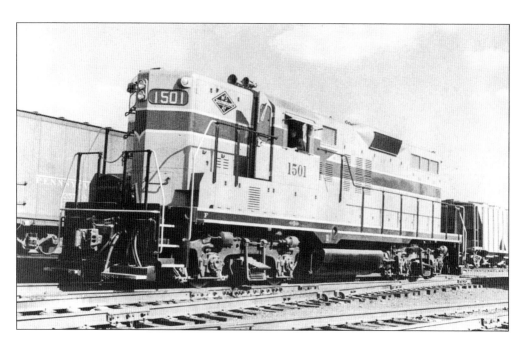

YADKIN RAILROAD (1891–1894, 1916–1951). Built by the Richmond and Danville, this 30.9-mile line from Salisbury to Albemarle became part of the Southern in 1894. The Yadkin was cut loose as an independent in 1916 but rejoined the Southern in 1951 as the Albemarle Division of the Carolina and Northwestern. (Above, SRHA/SM; below, Kenny Fannon collection.)

YADKIN RIVER RAILROAD (1912–1913). The Grandin Lumber Company's first railroad venture, the Yadkin River Railroad ran nine miles from North Wilkesboro to the community of Elkville. The company was reorganized as the Watauga and Yadkin River Railroad in 1913. (Doug Walker collection.)

YADKIN VALLEY RAILROAD (1989–PRESENT). Operator of 93 miles of leased Norfolk Southern lines from Rural Hall to both Elkin and Mount Airy, the Yadkin Valley is owned by the Gulf and Ohio Railways. (Alan Coleman.)

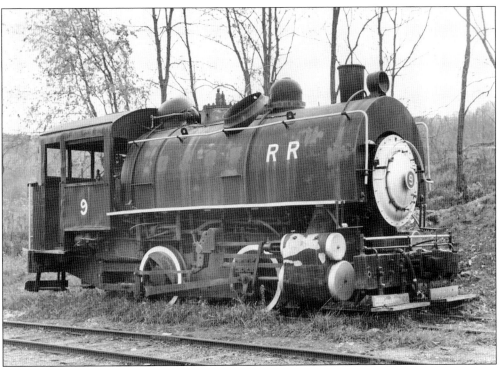

YANCEY RAILROAD (1955–1982). The successor to the Black Mountain Railroad, the Yancey connected with the Clinchfield at Kona and ran to Burnsville. The Yancey tried to find new income by hosting the Southern Appalachian Railway tourist line in 1969; dismal finances closed the Yancey Railroad in 1982. (Above, Mac Connery collection; below, Tom Sink, Marsh collection.)

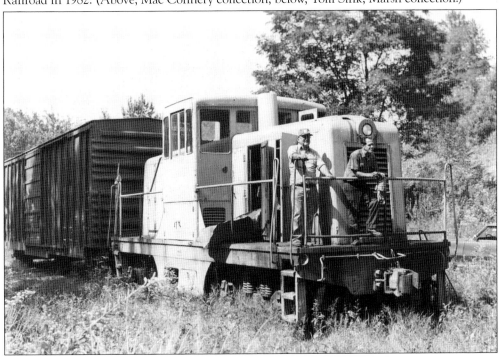

THE END OF THE CABOOSE. Cabooses on the end of trains in North Carolina were nearly extinct by the mid-1980s, replaced by end-of-train devices placed on the rear coupler of the last car. Two decades earlier, a Graham County Railroad caboose had braved a trip on the company's wobbly rails. (Richard D. Kehm.)

Two

RAILROAD HOLDING COMPANIES

As commerce matured in 19th-century America, the railroad industry was among the first to take advantage of a new category of business, the "holding company." In simple terms, the objective of a holding company is the ownership of enough common stock or securities in other companies to influence—or even better, to control—their management. Holding companies offered numerous benefits to the holding or "parent" company, including tax breaks; spreading losses among subsidiaries; and notably for the railroad industry, being able to control businesses that fell outside the limits of their state-granted charters

Over the years, railroad companies diversified their business interests through holding companies in such enterprises as real estate, steam-ship lines, moving-van companies, and even partial ownership of passenger airlines. The income from holding companies helped tide railroad company treasuries through difficult economic times. The late 1970s saw one of those difficult times; at that time, fully one-fourth of the railroads in the United States were in bankruptcy. The federal government took the drastic step of deregulating the railroad industry through the Staggers Act of 1980. New holding companies were among the beneficiaries of the act, as deregulation allowed the major railroads to sell or lease many of their unprofitable branch lines. This chapter describes two recent railroad holding companies in the state that have played a significant role in the operation of North Carolina short lines.

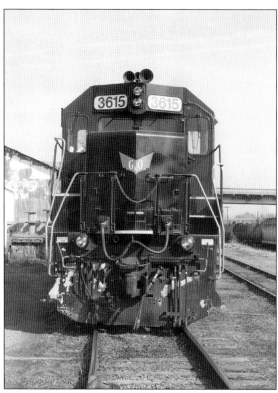

GULF AND OHIO RAILWAYS (1994–PRESENT). Knoxville-based and privately owned, the then-14-year-old Gulf and Ohio Railways purchased the Laurinburg and Southern Railroad and two of its parents' shortlines, the Yadkin Valley Railroad and the Nash County Railroad, in 1994. (Alan Coleman.)

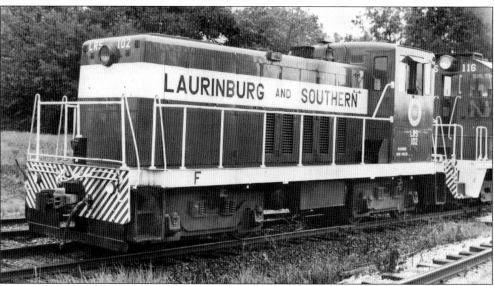

L&S HOLDING COMPANY (1984–1994). This holding company transformed the Laurinburg and Southern from a small railroad into one of the state's largest short-line operators and locomotive lessors. The L&S Holding Company bought or leased branch lines that became the Red Springs and Northern, the Fairmont and Western, the Franklin County Railroad, the Nash County, and the Yadkin Valley railroads. On February 28, 1994, four generations of Evans family ownership of the Laurinburg and Southern ended with the sale of the L&S Holding Company to Gulf and Ohio Railways. (Mac Connery.)

Three

COOPERATIVE VENTURES

It did not take long for even the fiercest competitors in the railroad industry to realize that cooperation, rather than confrontation, needed to define their working relationships. Along with the daily dependence on one another for interchange traffic, North Carolina's railroads also shared the reality that each was only a natural disaster or major accident away from being closed down for days or weeks. Trackage rights were negotiated, which permitted an affected company to detour its trains on the rails of more fortunate neighbors.

"Union stations" were a welcome answer to the problems facing towns that enjoyed service by more than one railroad company. Union stations brought travelers, mail, and express freight together under one convenient roof and lowered costs for all of the participating railroads. While most union stations in North Carolina were owned by one company and made available to other roads through trackage rights and operating agreements, at least three separate companies were established by the participating railroads to maintain and operate sizable union stations.

The economic advantages of cooperative ventures were not limited to union stations alone: the challenge of bridging two rivers to reach Wilmington united four competitors to create a railway bridge company that endured for nearly a century.

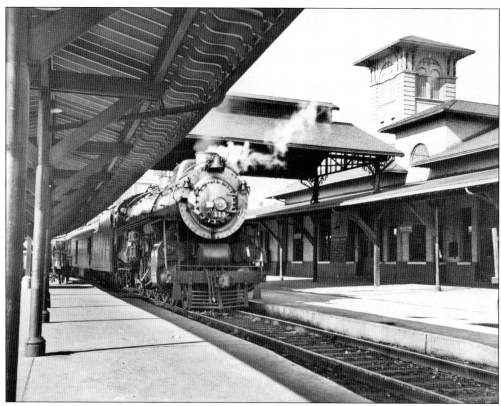

DURHAM UNION STATION COMPANY (1904–1965). Though limited to only .18 miles of track and the station, Durham Union Station served the Southern, the Durham and Southern, the Seaboard Airline, and the Norfolk and Western railroads. The company was dissolved in 1965, and its station was torn down in 1966. (Raymond B. Carneal, Mac Connery collection.)

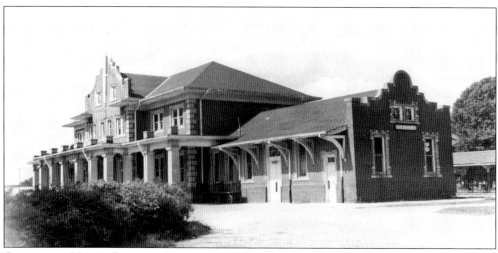

GOLDSBORO UNION STATION COMPANY (1908–1924). Jointly controlled by the Southern, the Atlantic Coast Line, and the Atlantic and North Carolina, this terminal company operated 1.35 miles of track. (Tom King, Marsh collection.)

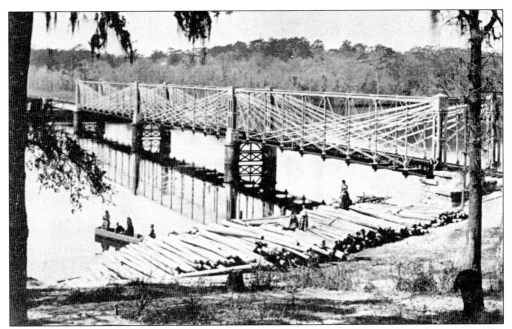

WILMINGTON RAILWAY BRIDGE COMPANY (1866–1956). Originally a 50/25/25 venture of the Wilmington, Charlotte, and Rutherford, the Wilmington and Manchester, and the Wilmington and Weldon railroads, this company built 2.5 miles of track between Navassa and Hilton and bridged the North East and Cape Fear Rivers to bring railroad service to Wilmington. By 1990, the company was coowned by the Atlantic Coast Line and the Seaboard Airline, which dissolved the firm in June 1956. (North Carolina State Archives.)

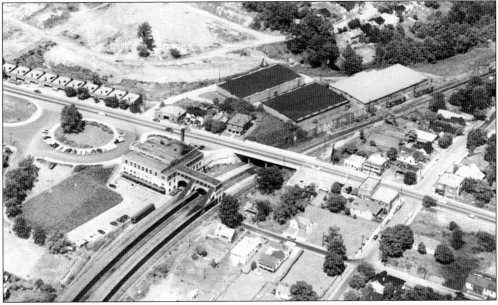

WINSTON-SALEM TERMINAL COMPANY (1926–1977). The Winston-Salem Terminal Company operated just over one mile of track and Winston-Salem's Union Station for the Norfolk and Western, the Southern, and the Winston-Salem Southbound railroads. The company met its demise with the end of passenger service to the city. (North Carolina State Archives.)

APPENDIX

To learn more about the following North Carolina railroads, which are not illustrated in this volume, please consult the Piedmont and Western Railroad Club's Web site, www.pwrr.org. This site also contains hundreds of photographs of North Carolina railroad depots, a list of railroad reporting marks, and both prototype and model railroad information.

Aberdeen and Asheboro Railway (1897–1907)
Aberdeen Forwarding Company (1892–1893)
Alamance Railway (1920–1922)
Albemarle and Raleigh Railroad (1883–1894)
Alma and Little Rock Railroad (1882–1890)
Alma Lumber Company (1895–1907)
Alma Railroad (1907–1911)
Apalachia and Cleveland Railroad (1902–1909)
Apalachia Railroad (1900–1902)
Appalachian Interurban Railroad (1905–1911)
Asheboro and Montgomery Railroad (1896–1897)
Asheville and Weaverville Electric Railway and Power Company (1901–1909)
Asheville Southern Railway (1906–1941)
Atlanta and Richmond Air Line Railway (1873–1887)
Atlanta, Knoxville and Northern Railway (1896–1905)
Atlantic and Western Railroad (1903–1927)
Atlantic Coast Line Railroad of Virginia (1900)
Atlantic, Tennessee, and Ohio Railroad (1860–1863; 1871–1894)
Bayside and Yeatesville Railroad (1885–1887)
Beaufort and Pamlico Railroad (1900–1905)
Beaufort and Western Railroad (1905–1937)
Beaufort Lumber Company Railroad (first) (1901–1903)
Beaufort Lumber Company Railroad (second) (1907–1933)
Belt Railroad of Durham (1891–1899)
Bladen, Columbus, and Florida Railroad (1882–1884)
Caldwell and Northern Railway (1893–1910)
Camp Bragg Railroad (1918–1919)
Camp Lejeune Railroad (1954–Present)
Carolina and Georgia Railway (1919–1927)
Carolina and Northeastern Railroad (1917–1931)
Carolina and Northeastern Railway (1931–1934)
Carolina and Tennessee Southern Railway (1909–1944)
Carolina and Yadkin River Railway (1912–1924)
Carolina Central Railway (1873–1880)
Carolina, Glen Anna, and Pee Dee Railway and Development Company (1905–1907)

Carolina Northern Railroad (1900–1905)
Carolina Railroad (1912–1931)
Carolina Rail Service (1994–2005)
Carolina Rail Services Company (1986–1994)
Carthage and Pinehurst Railroad (1907–1922)
Carthage and Western Railroad (1893–1898)
Cashie and Chowan Railroad and Lumber Company (1883–1913)
Cashie and Roanoke Railroad (1893)
Charleston, Cincinnati, and Chicago Railroad (1886–1894)
Charleston, Sumter, and Northern Railroad (1892–1895)
Charlotte and South Carolina Railroad (1852–1869)
Charlotte, Columbia, and Augusta Railroad (1869–1894)
Chatham Railroad (1871–1872)
Cheraw and Darlington Railroad (1892–1898)
Cheraw and Salisbury Railroad (1880–1892)
Chowan and Aulander Railroad (1902–1910)
Chowan and Southern Railroad (1886–1889)
Chowan River Railway and Baltimore Steamboat Company (1883–1886)
Clarksville and North Carolina Railroad (1888–1894)
Clinton and Warsaw Railroad (1887)
Consolidated Railways, Light, and Power Company (1901–1907)
Dawson Railroad (1868–1884)
Durham and Charlotte Railroad (1896–1911)
Durham and Northern Railway (1889–1901)
Duval Transportation (March–November 1987)
East Carolina Land and Railway Company (1893–1894)
East Tennessee, Virginia, and Georgia Railroad (1869–1886)
Egypt Railway of North Carolina (1892–1908)
Florence Railroad (1888–1898)
French Broad Railroad (1919–1925)
Glendon and Gulf Manufacturing and Mining Company Railroad (1893–1896)
Great Smoky Mountains Railroad (1988–Present)
Greensville and Roanoke Railroad (1827–1855)

Greenville and Vanceboro Railroad (1903–1911)

Halifax and Scotland Neck Railroad (1882–1883)

Hamilton Railroad and Lumber Company (1887–1895)

Hendersonville and Brevard Railway, Telegraph, and Telephone Company (1894–1899)

Hoffman and Troy Railroad (1891–1904)

Jackson Springs Railroad (1901–1907)

Kinston and Snowhill Railroad (1903–1913)

Kinston-Carolina Railroad (1910–1918)

Kinston Carolina Railroad (1918–1929)

Louisburg Railroad (1885–1901)

Madison County Railway (1911–1919)

Maxton, Alma, and Rowland Railroad (1889–1893)

Meherrin Valley Railroad (1882–1887)

Meherrin Valley Railway (1887–1892)

Midland North Carolina Railroad (1881–1883)

Milton and Sutherlin Narrow-Gauge Railroad Company (1878–1894)

Montgomery Railroad (1901–1904)

Moore Central Railroad (1945–1947)

Morehead and South Fork Railroad (2005–Present)

Murfreesboro Railroad (1892–1896)

Narron Central Railroad (1918–1924)

New Hanover Transit Company (1887–1895)

Norfolk Southern Railroad Company (1883–1891)

Northampton and Hertford Railroad (1893–1911)

Northampton and Hertford Railway (1911–1917)

North and South Carolina Railroad Company (1899)

North Carolina Mining, Manufacturing, and Development Company (1903–1905)

Ocona Lufty Railroad (1918–1932)

Oxford and Clarksville Railroad (1888–1894)

Oxford and Coast Line Railroad (1902–1906)

Oxford and Henderson Railroad (1881–1894)

Palmetto Railroad (1887–1895)

Palmetto Railway (1895–1900)

Pamlico, Oriental, and Western Railway (1905–1906)

Petersburg Railroad (1833–1898)

Piedmont Railroad Company (1864–1880)

Piedmont Railway (1909–1912)

Piedmont Railway and Electric Company (1912–1920)

Pittsboro Railroad (1885–1901)

Portsmouth and Roanoke Rail Road (1836–1845)

Raleigh and Augusta Air-Line Railroad (1871–1900)

Raleigh and Eastern North Carolina Railroad (1903–1905)

Raleigh and Pamlico Sound Railroad (1905–1906)

Raleigh and Western Railway (1893–1909)

Raleigh, Charlotte, and Southern Railroad (1912–1914)

Randolph and Cumberland Railroad (1906–1907)

Red Springs Railway and Lumber Company (1888–1896)

Richmond, Petersburg, and Carolina Railroad (1892–1900)

Roanoke and Tar River Railroad (1887–1911)

Roanoke Railroad and Lumber Company (first) (1889–1901)

Roanoke Railroad and Lumber Company (second) (1887–1900)

Roanoke Railway (1914–1926)

Roanoke Valley Railroad (1855–1863)

Rowland Lumber Company (1921–1935)

Sanford and Glendon Railroad (1909)

Sanford and Troy Railroad (1910–1912)

Seaboard and Raleigh Railroad (1873–1882)

Seaboard and Roanoke Railroad of Virginia (1846–1849)

Snowbird Valley Railroad (1908–1916)

South Carolina and Georgia Extension Railroad (1898–1902)

Southeastern Railroad (1897–1900)

Spartanburg and Asheville Railroad (1878–1884)

Statesville and Western Railroad (1887–1894)

Swannanoa Railroad (1911–1916)

Troy Manufacturing Company (1899–1901)

U.S. Railroad Administration (December 28, 1917-March 21, 1920)

Virginia and Carolina Coast (1906)

Virginia Southern Railroad (1988–1996)

Waccamaw Railroad (1909–1911)

Wellington and Powellsville Railroad (1893–1926)

Whiteville Lumber Company Railroad (1902–1916)

Whiting Manufacturing Company (1906–1912)

Wilmington and Carolina Railroad (January 1870–April 1870)

Wilmington and Conway Railroad (1895–1896)

Wilmington and Manchester Railroad (1853–1870)

Wilmington and Raleigh Railroad (1840–1855)

Wilmington, Chadbourn, and Conway Railroad (1886–1895)

Wilmington, Charlotte, and Rutherford Railroad (1857–1873)

Wilmington, Columbia, and Augusta Railroad (1870–1888)

Winton Railroad (1891–1899)

Winton Railroad and Lumber Company (1899–1902)

Discover Thousands of Local History Books Featuring Millions of Vintage Images

Arcadia Publishing, the leading local history publisher in the United States, is committed to making history accessible and meaningful through publishing books that celebrate and preserve the heritage of America's people and places.

Find more books like this at
www.arcadiapublishing.com

Search for your hometown history, your old stomping grounds, and even your favorite sports team.

Consistent with our mission to preserve history on a local level, this book was printed in South Carolina on American-made paper and manufactured entirely in the United States. Products carrying the accredited Forest Stewardship Council (FSC) label are printed on 100 percent FSC-certified paper.

MADE IN THE USA